DRAWING
TODAY

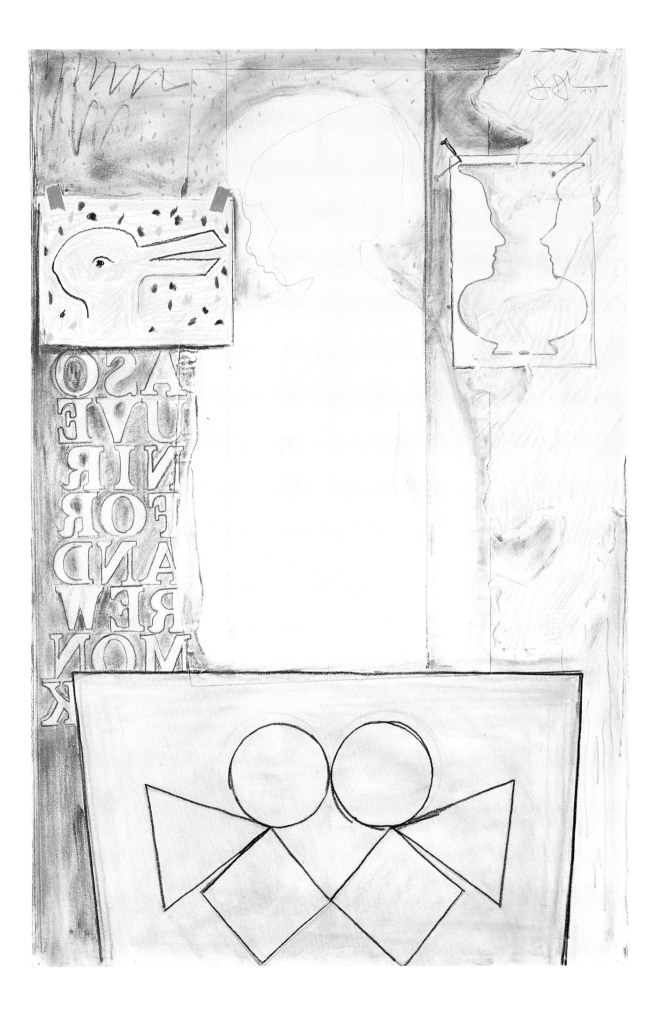

DRAWING TODAY

DRAUGHTSMEN IN THE EIGHTIES

tony godfrey

PHAIDON · OXFORD

PHAIDON UNIVERSE · NEW YORK

PHOTOGRAPHIC ACKNOWLEDGEMENTS

The author and publisher wish to thank the following galleries for supplying photographs and agreeing to their publication:

Chapter One. Jasper Johns: Leo Castelli Gallery, New York; Robert Smithson: John Weber Gallery, New York; Cy Twombly: Anthony d'Offay Gallery, London.

Chapter Two. Jasper Johns: Leo Castelli Gallery, New York; Philip Guston: David McKee Gallery, New York; Brice Marden: Anthony d'Offay Gallery, London; John Walker: Knoedler Gallery, New York; Cy Twombly: Anthony d'Offay Gallery, London; Joseph Beuys: Anthony d'Offay Gallery, London.

Chapter Three. Sol LeWitt: John Weber Gallery, New York; Richard Long: Anthony d'Offay Gallery, London; Andy Goldsworthy: Fabian Carlsson Gallery, London; Arnulf Rainer: David Nolan Gallery, New York; Susan Hiller: Pat Hearn Gallery, New York; Edward Allington: Lisson Gallery, London; Bruce Nauman: Leo Castelli Gallery, New York; Robert Longo: Metro Pictures, New York; Edward Ruscha: Karsten Schubert Gallery, London; Guiseppe Penone: Salvatore Ala Gallery, New York; Jonathan Borofsky: Paula Cooper Gallery, New York.

Chapter Four. R.B. Kitaj: Marlborough Fine Art, London; Avigdor Arikha: Marlborough Fine Art, London; Lucian Freud: James Kirkman Ltd., London;

Frank Auerbach: Marlborough Fine Art, London; Philip Pearlstein: Hirschl and Adler Modern, New York; Andy Warhol: Robert Miller Gallery, New York; Alice Neel: Robert Miller Gallery, New York; Paula Rego: Marlborough Fine Art, London; Pierre Klossowski: Galerie Maeght Lelong, Paris; Werner Tübke: Galerie Brusberg, Berlin.

Chapter Five. Georg Baselitz: Michael Werner Gallery, Cologne; A.R. Penck: Michael Werner Gallery, Cologne; Anselm Kiefer: Anthony d'Offay Gallery, London; Walter Dahn and Georg Jiri Dokoupil: Galerie Paul Maenz, Cologne; Francesco Clemente: Anthony d'Offay Gallery, London; Arcangelo: Edward Totah Gallery, London; Enzo Cucchi: Anthony d'Offay Gallery, London; Robert Morris: Leo Castelli Gallery, New York: Per Kirkeby: Michael Werner Gallery, Cologne.

Chapter Six. Donald Sultan: Blum Helman Gallery, New York; Mel Bochner: David Nolan Gallery, New York; Joel Shapiro: Paula Cooper Gallery, New York; Shirazeh Houshiary: Lisson Gallery, London; Rosemarie Trockel: Monika Spruth Gallery, Cologne; Robert Wilson: Paula Cooper Gallery, New York; Pat Steir: Knoedler Gallery, New York; Hughie O'Donoghue: Fabian Carlsson Gallery, London; Manfred Stumpf: Galerie AK, Frankfurt; Adrian Wiszniewski: Nigel Greenwood Gallery, London; Avis Newman: Lisson Gallery, London; Su Arrowsmith: Anthony Reynolds Gallery, London.

All other photographs courtesy of the artist directly.

Published in Great Britain by Phaidon Press Limited, Musterlin House, Jordan Hill Road, Oxford OX2 8DP

ISBN 0 7148 2567 0

A CIP catalogue record for this book is available from the British Library

First published 1990
© Phaidon Press Limited 1990
Text © Tony Godfrey 1990

Published in the United States of America by Phaidon Universe, 381 Park Avenue South, New York, N.Y. 10016

ISBN 0-87663-601-6

A CIP catalog record for this book is available from the Library of Congress

Designed by Michael Morey
Typeset by Tradespools Ltd, Frome, Somerset
in Linotype 10/14pt Frutiger
Printed in Singapore under co-ordination of
C S Graphics Pte Ltd

Frontispiece: JASPER JOHNS. *A Souvenir for Andrew Monk*. 1987. Chalk, charcoal, graphite and collage on paper, 106.7 × 71.1 cm (42 × 21 in). Private collection

CONTENTS

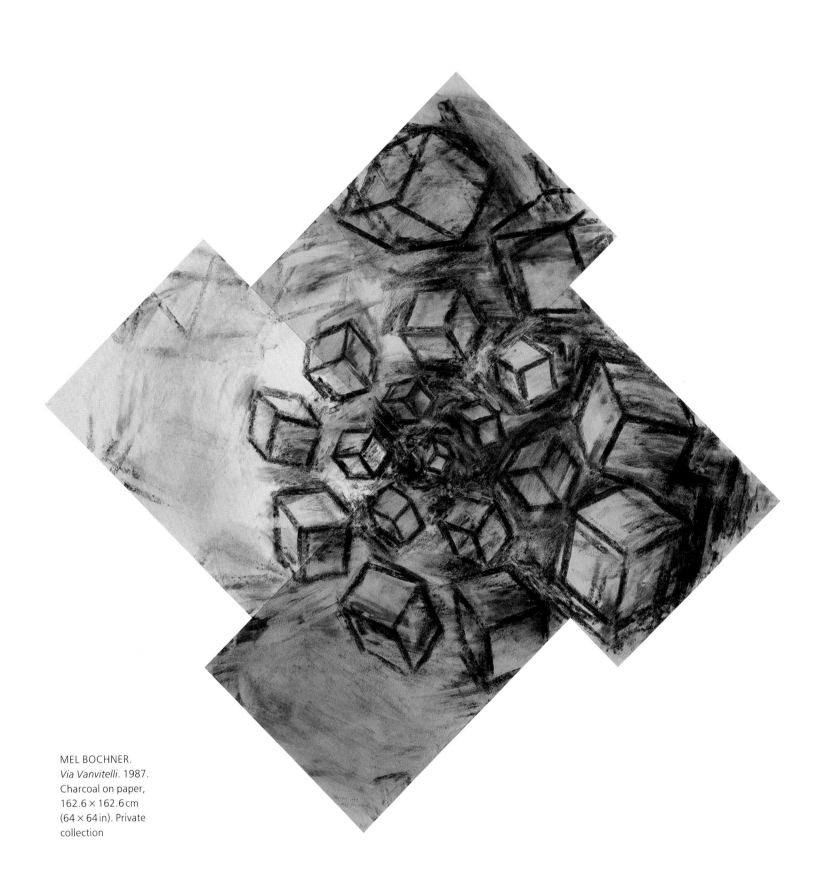

MEL BOCHNER.
Via Vanvitelli. 1987.
Charcoal on paper,
162.6 × 162.6 cm
(64 × 64 in). Private
collection

PREFACE

Drawing is a passionate affair

Drawing is not just a medium or a technique: it is a human activity with a rich and complicated history; it is an activity rooted in psychological needs and drives. In some respects drawing remains the oldest and most unchanging thing in art, but in other ways over the last twenty-five years it, and the way it is used, has changed very remarkably. These changes are difficult to gauge precisely: they are obviously not merely technical (the use of felt-tipped pens), nor merely stylistic (the recent prevalance of long, loopy lines), but, more significantly they are responses to problems in culture at large. In bearing witness both to continuity and change this book touches on issues of psychology, myth and the politics of the mass-media. These are not tangents: they are critical areas in which drawing is engaged. It is part of the nature of drawing now that this book cannot be a benign or bland survey of artists and styles. Although it offers a representative selection of contemporary drawing, this book must be, of its nature, argumentative, provocative and, at times, paradoxical. There are important matters at stake here.

The number of artists seriously making drawings in the Western World amounts to millions: just over sixty are considered in this book, constituting a tiny fraction of that mass. They do, however, indicate the diverse shifts and aspirations in drawing today. Everyone will find some omission or inclusion that they disagree with: some will think it blasphemous to include Bruce Nauman's *Storage Capsule for Henry Moore*, but none of Moore's late drawings; some will look in vain for Lichtenstein or Rauschenberg. Irrespective of the quality of what those artists did in the eighties, it seems to me that they added nothing new to drawing as a whole, that they did not contribute significantly to the argument surrounding the nature of drawing. Contrariwise, some much older work such as that of Smithson or Neel, as it is re-evaluated today, speaks in a way it had not done so before.

There are, I believe, many good drawings here. Above all else, in its variety, energy and critical stance, drawing now gives us much to both enjoy and argue with.

'Conceivably, drawing may be the most haunting obsession the mind can experience . . . But is it quite, after all, a question of mind?

Things stare us in the face. The visible world is a perpetual stimulant, constantly maintaining or arousing the instinct to master the outline or the volume of that thing which the eye constructs.

Or the desire for a more precise image of the impression in the mind prompts us to pick up a pencil, and at once a curious and at times violent contest begins, in which this desire, along with chance, memory, the skill and variable proficiency of the hand, the idea and the instrument are all engaged in an interchange whose more or less felicitous foreseeable result consists of pencil strokes, shadings, shapes, the appearances of places and living things . . . in short the work.

It can happen that this creative design, intoxicating the draughtsman, becomes a violent, self-devouring activity, reinforcing, precipitating, and aggravating itself, an impetuous impulse rushing upon its own fulfillment, upon the possession of what one wants to see.

All the indeterminacy of the mind, like the whole empty space to be covered, is attacked, invaded, possessed by a necessity that grows more and more precise and insistent.

The soul of the mind requires marvelously little stimulus to make it produce all that it envisages, and employ all its reserve forces in order to be itself, which it clearly knows it is not until it is very different from its ordinary condition. It does not want to submit to being what it most frequently is.

A few drops of ink, a sheet of paper as material for the accumulation and co-ordination of moments and acts, are all that is required.'

PAUL VALERY
(Degas, Dance Drawing, 1938)

DRAWING: *AN ARCHAEOLOGY OF THE ACT OF TOUCHING*

A small girl is running down the street, in her hand a stick. She holds out the stick so that it bangs against each of the railings as she passes them. On the railings is left a trail of marks.

Surreptitiously, an adolescent takes out a felt-tipped pen from his pocket as he stands on a train station platform. He scrawls a moustache on the poster of a movie star.

Asked for directions, a man takes out a stub of pencil and some paper and makes a rough map.

A cup is kicked over and spilt coffee flows across the floor, leaving a dark trace behind.

Desperately, in an emergency, a car brakes. The black skid marks on the road show where it careered out of control.

Drawings are everywhere. Wherever two objects or two materials touch (stick and railing, pencil and paper, liquid and earth, rubber and tarmac) evidence of their meeting is left behind. To examine such drawings is to excavate, to muse over activity in the past. They present us with the archaeology of acts of touching.

Drawing is the most democratic of art forms. We all draw: whether making a plan of some alteration to our house; doodling as we talk on the telephone, occupying an idle hand; or covering up something that irritates us. We draw to explain something; we draw to fill in time and space; we draw to deface some other picture. However self-depreciatory we may be of such drawings, they often fulfill some more vital need.

As infants we learn to draw before we learn to write. One could argue that writing is but a special form of drawing. As one experiments with drawing one learns to conceptualize the world and its objects. Lines unthinkingly made, soon coagulate into structures that intimate some form and meaning beyond undifferentiated marks. Two lines cross each other. A line turns round and completes itself.

It is essential to remind oneself of all this because the nature of drawing in contemporary art is not quite what it used to be. Meticulous drawings after plaster casts and after the nude model once formed the basis of art education. This is no more. Nowadays, to most art students, the doyens of such mimetic drawing, Raphael and Ingres, seem as distant and exotic as artists from a long dead and far distant culture. Drawing twenty-five years ago, in a period of vast stained canvases and geometrically derived sculptures, and then later in the seventies, in a period notable for anti-object performance and conceptual art, seemed unimportant. Its resurgence as a pre-eminent experimental medium must be traced not to academic practice, but to its roots in myth and in the ordinary human psyche and its activities.

Classical myth tells of how art was invented by a Corinthian maid, the daughter of Butades, who, her hand guided by Cupid, traced the outline of her sleeping lover's shadow on the wall. When Jasper Johns traces the shadow of the child Andrew Monk in like manner we are made conscious of how, though Johns is amongst the most sophisticated of artists, something basic has not changed. Drawing is both a physical thing and an act of sympathetic magic. It is a way of both representing the world and bringing forth something new. It is a way of copying, and of creating. The same may be said of the palaeolithic drawings in the caves at Lascaux, which have been seen as the beginnings of Western art. There is an enduring fascination with the power of drawing to evoke images. There is an enduring obsession with the activity of tracing lines, with making marks.

Despite the profusion of books on contemporary art, there is little on drawing *per se* in contemporary art. What there is we may profitably argue

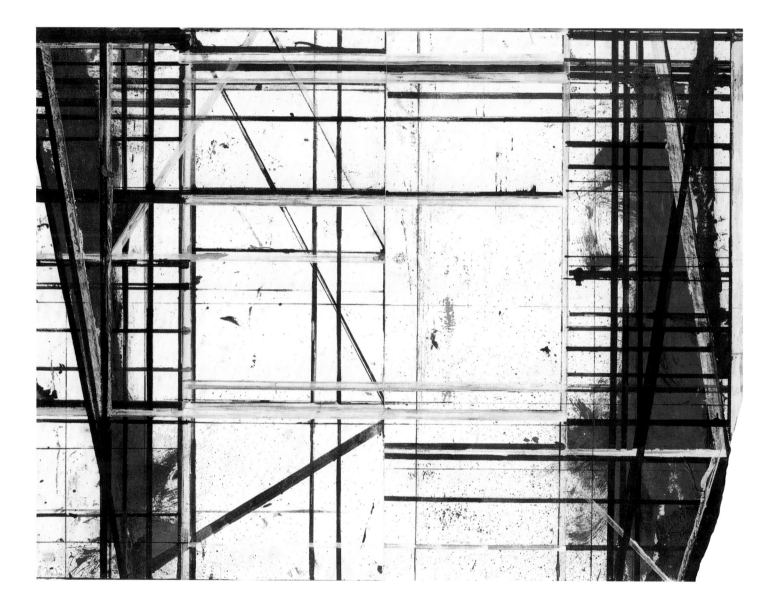

1 BRICE MARDEN. *Masking Drawing 3 (Red Diptych)*. 1984. Gouache, graphite, ink and oil on paper, 36.8 × 48.9 cm (14¹/₂ × 19¹/₄ in). Private collection

2 R.B. KITAJ. *The Yellow Hat*. 1980. Pastel and charcoal on paper, 77.5 × 57.8 cm (30¹/₂ × 22³/₄ in). Private collection, London

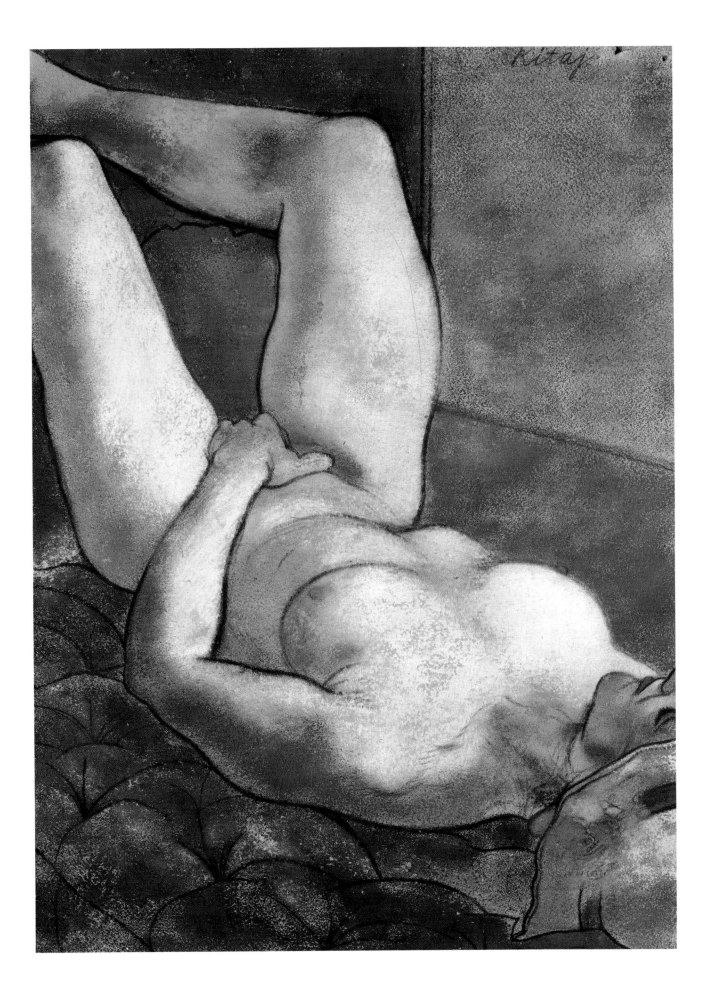

with. John Elderfield's book *Twentieth Century Drawing* we may oppose partly for its emphasis on pure connoisseurship, but above all because he uses the New York Museum of Modern Art's definition of a drawing as an art work on paper. What a drawing is should be defined more by the activity that initiates it rather than by the material it leaves its traces on. Quite apart from the fact that the Museum of Modern Art's definition expels those first drawings at Corinth and at Lascaux, it banishes many of the works that, be they on walls, objects, the ground, or in the air, have been pre-eminent in extending drawing's current status and meaning. (A less restrictive working definition could be: 'A group of related marks, probably linear, left by an object or objects touching a surface; the surface itself will normally remain partially visible around these marks. Such a combination of marks and surface will seem to intimate some meaning.' However, such definitions, even one as cagey as this, are in Art more honoured in the breach than in the observance.)

Rudi Fuchs in his recent book on Richard Long describes Long's early work, *Line Made by Walking* (1967), as a key work which, like Malevich's *Black Square*, 'cancelled previous art in one grand, abrupt statement of conviction.' This no doubt overstates the case, but, nevertheless, Long's work is provocative in its emphasis both on physical activity and on the very artwork's impermanence. (It was made by walking repeatedly back and forth in a field until a distinct, if temporary, line was marked out by the crushed blades of grass. The work was only recorded by a black and white snapshot.) In this and subsequent walk-generated pieces, Long seemed to propose that in an age of threatened ecological disaster, in which we are increasingly estranged from nature, art should touch the world sensitively and discreetly, not impose itself in an arrogant or aggressive manner. Often in inaccessible places, the lines made with rocks, or twigs, or by cutting grooves in the turf, such works are generally known only by laconic written descriptions, or by photographs. Although

Long has tended to call such work sculpture it could be argued that they are very much an extension of a drawing process. In turning away from accepted art media, (including traditional drawing, which, with its academic and life-room associations, was then seen as especially archaic by young, radical artists) Long had extended Paul Klee's definition of a line as a point taken for a walk to that of a figure taken for a walk.

In his use of a few rudimentary shapes, particularly the spiral and concentric circles, Long emphasized the mythic and universal nature of such drawing activity. Even more explicit in its conjunction of the ostensibly physical and the mythic was Robert Smithson's *Spiral Jetty* of 1970 which, though it was a major construction project, that involved moving tons of earth and rock, could be seen as being as much a drawing on the earth's surface as the Nazca lines in Peru, or the Cerne Abbas Giant that is cut into the chalk hills of England.

Made not long before his untimely death in 1973, Robert Smithson's drawing *Entropic Landscape* (Pl 3) was a presager for much of the drawing of the next two decades. Influenced by Piranesi's images of ruins and convoluted prison interiors, the straightforward lines (not unlike those an engineer would use), are juddered up against the mythic impracticality of the visionary artist. The marks alternately describe things or, as with the flows of mud or tar on the hills, assume their own intrinsic vitality. An area such as that on the front island with its jaggy triangles seems the result of some self-generating process. We remain uncertain whether to read the drawing as cool conceptualization or autographic, even passionate.

Smithson's drawing can be seen to lock together two different types of drawing, types best defined in Lawrence Alloway's 1975 essay on Sol LeWitt: 'There is the notion of drawing as graphological discourse, the most direct marks that an artist can make and hence, because of their intimacy, authentic evidence of the artist's presence. Personal touch is highly valued on this basis.

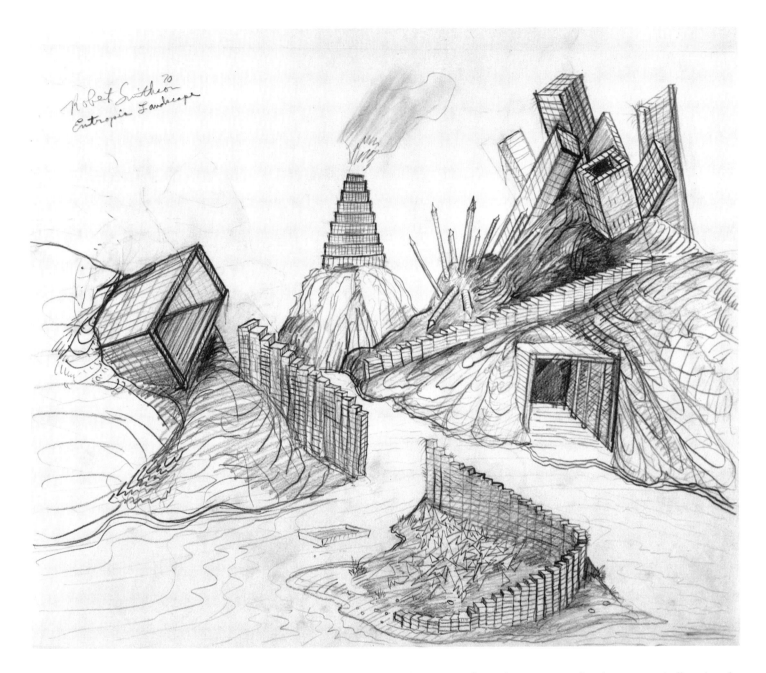

Robert Smithson 70
Entropic Landscape

3 ROBERT SMITHSON.
Entropic Landscape. 1970.
Pencil on paper,
48.3 × 61 cm (19 × 24 in).
Private collection

There is another notion, which is that drawing represents not genetic freedom but the artist at his most rigorously intellectual. In this sense drawing is the projection of the artist's intelligence in its least discursive form: line is the gist, the core of art.' Bernice Rose in her 1976 book, *Drawing Now* takes this text as a starting point and like Alloway sees in LeWitt's drawings the two notions reconciled – albeit with a heavy weighting to the intel-

lectual or conceptual. In fact, as we shall see in subsequent chapters, LeWitt's work is an extreme example: most artists who, like LeWitt, emerged from conceptual or post-conceptual art have used drawing, not so much to extend the intellectual, but rather to introject the irrational into predetermined situations, be it a grid or a set of instructions. I am inclined to see, not a reconciliation, but a vigorous struggle between these two

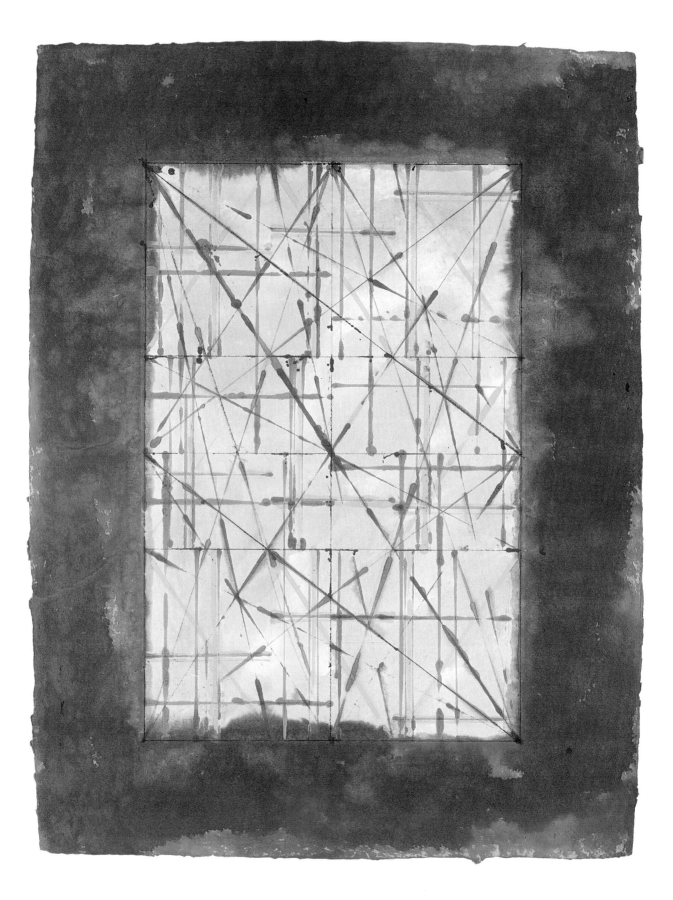

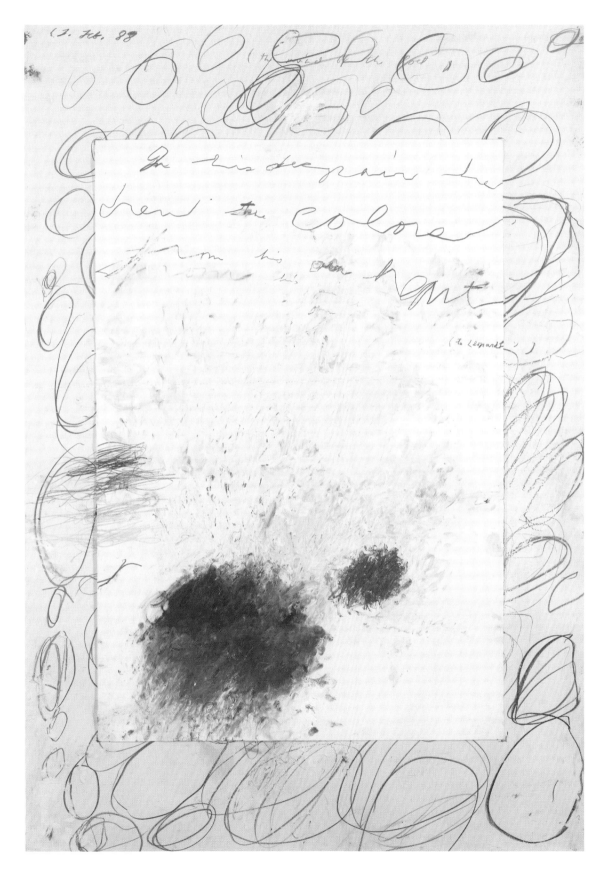

5 CY TWOMBLY.
Untitled. 1988. Ink, pencil
and crayon on paper,
139.7 × 97.8 cm
(55 × 38¹/₂ in). Private
collection

(*opposite*)
4 BRICE MARDEN.
*Untitled (Window Study
No. 1)*. 1983. Ink on paper,
57.1 × 45.8 cm
(23¹/₄ × 18 in). Private
collection

6 CY TWOMBLY.
*To Imagine a Language Is
to Imagine a Form of Life*.
1983. Watercolour, pencil
and tempera.
57.2 × 38.1 cm
(22¹/₂ × 15 in). Private
collection

ture of loaded imagery, gestural handling and stylistic variety.

A third author to be argued with is Philip Rawson whose book *Drawing*, for all its coherence and brilliance in categorizing old master drawings, signally fails to tackle contemporary drawing. Symptomatically when in a later book, *Seeing through Drawing*, he collaborates with two artists they are the traditionalists, David Hockney and Jim Dine. Rawson's constant appeal is to 'a language of marks' that tell us what is seen and what is known of something. 'With drawing,' Rawson writes, 'as with spoken language, there is a common factor among all the various uses, the common underlying structure of the "language" itself, with its grammar and syntax . . . the art of drawing is, in a way, just like language: you can use it to convey all sorts of different messages. Just as our spoken and written language can be used to tell jokes, preach sermons, play politics, record industrial information, write lyric poetry, make love to someone, express complex feelings and attitudes, or have a simple conversation, so you can use drawing to do a similar range of things.' This is disingenuous: *giving* a drawing to someone may be an act of love, but drawing *per se* is unlikely to communicate such information. Like the rest of the population I have yet to have a simple conversation in drawings. How do you ask what the weather is like with a drawing? Do you ask your boss for a pay rise with a drawing?

At the heart of contemporary drawing is a question about this supposedly linguistic equivalence of drawing. What is the linguistic meaning of one of Brice Marden's early drawings, where a grid is systematically covered with graphite so that the marks become opaque, and which if, as is normally the case, framed behind glass becomes reflective like a mirror? The drawing has indubitable presence, but its meaning is as apparently opaque as its graphite surface. In the past we may agree that the Corinthian maid communicated what her lover's profile looked like, but would we find her drawing communicated the degree of passion that

types of drawing, as being the mainspring of drawing now. Though still a useful book, Rose's arguments have been overtaken not only by developments in post-conceptual art, but also, from the mid-seventies, by a resurgence of representational drawing, with its faith in the life room and, around 1980, the rise of what has been crudely termed neo-expressionism, with its mix-

she felt for him? If drawing in this example is like a language it is more like body-language, than written or spoken language. Alternatively, rather than seeing drawing as language, we should see it as the residue of an activity, perhaps similar to the footprints that a dancer will leave in the sand, or perhaps similar to the rucks and coruscations left in the beach by the receding sea. These marks may not be intentionally meaningful, they may not use a 'language', but they will reveal patterns, relationships, even a satisfying coherence.

To Imagine a Language Is to Imagine a Form of Life (Pl 6), a drawing by Cy Twombly, brings to the fore many of these problems. In what way is this a language? What do these scrawls and smudges speak? This alternate stutter and flow of line? As we trouble over the drawing we respond with a mixture of repulsion, attraction, bafflement and recognition. What is it that makes this a drawing, and not just a messy bit of handwriting? What form of life could use such a language – the answer (and there's the rub) must be that because we can respond to it, however partially, this form of life is in some way hidden within us. Understanding it (being intrigued by it, feeling relaxed with it, enjoying it) as a drawing is to savour it as a possible form of life. It is also to comprehend it as the result of a shared compulsion; it is to realize, as Valery wrote over fifty years ago (in the quotation at the beginning of this book), that drawing is 'the most haunting obsession'; it is to realize that we are here talking about a 'necessity'.

We are entering a field in which excitement and uncertainty are mingled, where the reward may be uncomfortable self-knowledge rather than reassurance. There are irreducable problems about meaning in drawing today, and, as their corollary, problems in how to determine quality in drawings. Our language is woefully insufficient to explain what we experience in drawing. As we seek to find clear cut definitions for drawing, paradoxes lie in wait like mantraps in the jungle. The gnomic utterances made by Ian McKeever in 1982 on drawing ring more true in their quizzicality than more instrumental or blander explanations would:

'The order inherent in drawing always edges towards chaos.'

'One is using an activity that is full of contradictions, in that like a mirror, a drawing allows alienation and intimacy to co-exist.'

'Looking at drawings is like listening to other people's conversations, one is never quite sure what is being said.'

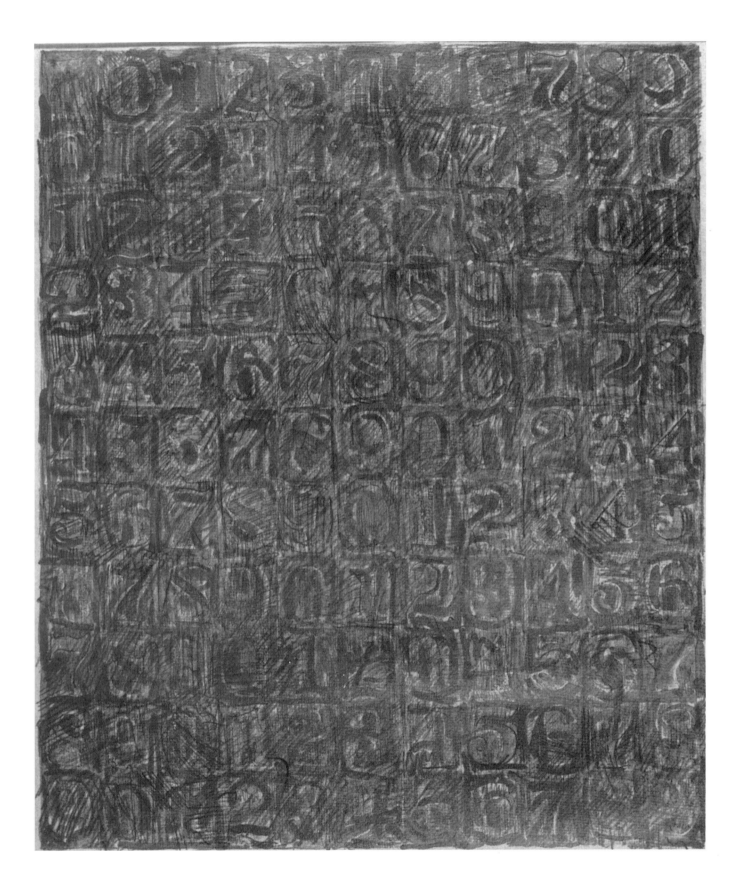

2 SIX DRAUGHTSMEN: *FEELING, TOUCHING, DRAWING*

'. . . the hand touches more delicately in drawing. There is less between the hand and the image than in any other media.'

BRICE MARDEN

To examine drawing in the eighties we must look not only at the work of artists whose reputations emerged at that time, but also at the work of longer-established artists which, developing from past successes, changed as new stimuli arrived. This is particularly true of artists such as Johns, Guston, Marden, Twombly, Walker and Beuys. An analysis of their work provides a good introduction to the issues taken up in recent years.

The work Jasper Johns did in the late fifties and early sixties is still of crucial importance. He took the abstract expressionist mark, with its supposed freedom and inspirational authenticity, and analysed it with both methodological rigour and wit. In a drawing such as *Numbers* (Pl 7) from 1966 there is a tension between the ostensible subject matter, a grid of numbers, and the lines which bustle about like randomly excited electrons. In such drawings there is no depth: the subject, be it a flag, numbers, letters or skin, is flat with the paper. Often it is traced or stenciled onto the paper. The subject matter seems to provide little drama or narrative. At the risk of being tautological, the drawing is in the drawing. The meaning is in the process; mood and emotion in the fluctuations of tone that shift across the page like shadows of clouds on a changeable day. The marks themselves seem small, fidgety, with no pretension, even inconsequential, like coin rubbings. Significance is something achieved *in absentia*.

Although the development of his drawings up to the eighties has been logical, even methodical, they are quite different. Replete with visual jokes and *trompe l'œil* effects they inevitably induce an expectation of symbolism or allegory. Drawing for

Johns has become an unending meditation on past art in which the motifs are taken from his own past work as well as from Grünewald, Leonardo or Munch. Such motifs jolt when put alongside optical conundrums, a rabbit's head that is also a duck's, a vase that can be read as two profiles. In the four *Seasons* paintings of 1986 Johns' own shadow was traced onto the canvas. In *Spring* in front of his own shadow also appeared the traced shadow of the three year old Andrew Monk. A year later the child's outline appears again in the drawing *A Souvenir for Andrew Monk* (Frontispiece). The drawing has a poignancy and intimacy that a painting could not have. In this lyrical and beautiful drawing the conceits of the reversed writing take on a new meaning, for it is as though the child is on the other side of a window looking back at the stencilled letters. The images which elsewhere seemed part of a sombre reflection on mortality here have the playfulness appropriate to a child's wonder at the world. The triangles, squares and circles which elsewhere recall Durer's *Melancholia* here become building blocks for his play. If most of the drawing is created, as normally, with tonal variations, the two drawn outlines of the head that remain as *pentimenti* and the speckling in the top left hand corner produce a somewhat unsettled mood. The drawing is about age and time.

If the outline of the child should look as though it is pressed against a window, we may recall that in the sixties and seventies Johns did a series of drawings entitled *Skin* where the paper was rubbed against his own hand or buttocks so that shadowy images of his own body appeared. Skin is

(*opposite*)
7 JASPER JOHNS. *Numbers*. 1966. Pencil and graphite wash on paper, 65.4 × 54.9 cm (25^3/$_4$ × 21^5/$_8$ in). Private collection

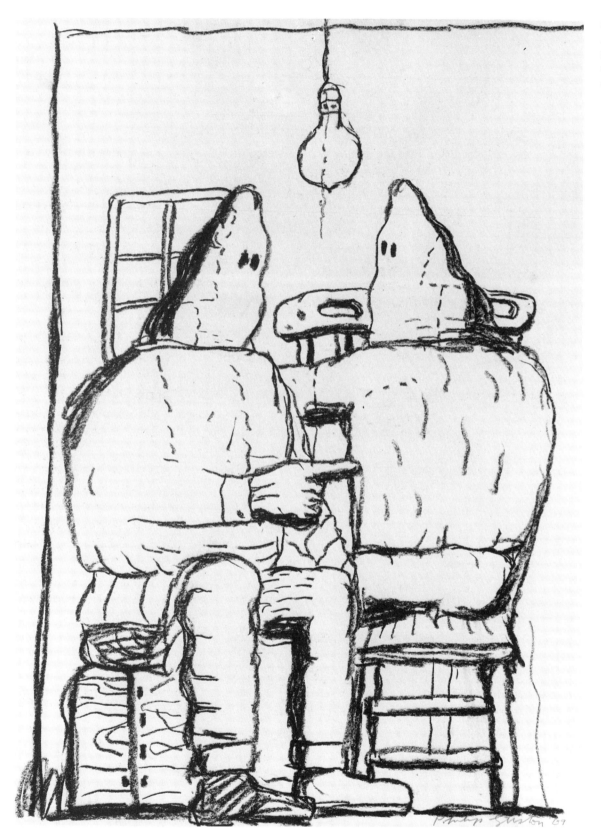

8 PHILIP GUSTON.
Discussion. 1969. Charcoal
on paper, 61 × 44.5 cm
(24 × 17^1/$_2$ in). Private
collection

for Johns, as it is for an artist like Penone, a synonym for both drawing and our undervalued sense of touch.

Although most abstract expressionists, notably de Kooning, continued to work with a cursive line rooted in automatic drawing, one, Philip Guston, was to turn against it. In the late sixties, faced with both existential doubts and troubled by the national malaise caused by the Vietnam War, he hankered after an art less concerned with technique. At the time he was making austere minimal drawings, but would also, at night, he tells us, 'go out to the studio to do drawings of objects — books, shoes, buildings, hands — feeling *relief* and a strong need to cope with tangible things. I would denounce the pure drawings as too thin and exposed, too much ''art'', not enough nourishment.' Lying down in this 'rag and bone shop of the heart' was linked with finding an apparently unaffected way of drawing. Soon the basic objects were joined by hooded Ku-Klux-Klan figures (Pl 8). It was a way of exorcising the ghosts of that period, to whose violence he felt an ambiguous fascination. 'I almost tried to imagine that I was living with the Klan. What would it be like to be evil? To plan, to plot.' Drawing has always provided the handiest way of empathizing, of fantasizing about ourselves as others, searching for some shadow of our personality that we cannot spot in daylight.

There is a directness to these drawings that many people have connected to the influence of cartoons, especially those of Robert Crumb (of whose work Guston was apparently at this time unaware). There is a conscious un-artiness to them, a concern with stating things clearly, even bluntly, but it should be noted that Guston was a devotée of Piero della Francesca and Nicholas Poussin. His simplicity is like their's a classicizing one. The hooded figures could as well be boulders, or filled sacks, or monuments. These drawings, once we get over their upturning of modernist decorum, are more architectural than raucous. If this comes from the unconscious, or touches it, it hints that such structural motifs can be as strange and

evocative as any hyperactive and overtly emotional gesture. The laconic quality of the outline and the cursory shading emphasize the thinginess, the quiddity of what is drawn. There is a tragic aspect to this representation of people as things that we will find elsewhere.

One of the seeming paradoxes in the art of Brice Marden is that at the same time that he was making austere monochrome paintings and opaque graphite drawings, like those referred to above, he published a book of drawings, *Suicide Notes* (1974) where a set of variations on the window motif was drawn with tense, trembling lines. Handwritten messages in these drawings hinted at fraught personal emotion: 'these are suicide notes', 'I don't know what my mind means!?'. However austere the framework, emotion was ploughed into drawing. In 1979 he wrote, 'the hand touches more delicately in Drawing. There is less between the hand and the image than in any other media.' The engagement of hand with paper becomes at once more exposed, perilous and more sensitive, sensual. There is a greater likelihood of either joy or danger.

His drawings show an unending attempt to unite geometric structures with the autographic: the grid with slippages in it, a machine that is functionally perfect but creates noise. In the early eighties this was extended into a series of studies for a stained glass window in Basle cathedral (Pl 4). In these it is no longer the window frame he marks out, but the lines of coloured light coming through the window. The meanings lie in these lines, or marks, not in the boundaries. Whereas before the drawing had been about closing down, here it became about opening out, revealing light.

Weary of the over-refinement of the monochromes he increasingly turned to nature to get more energy into his art. On the Greek island of Hydra he will often sit under an olive tree and draw, responding to things in the landscape. In 1984 he began collecting shells: many recent drawings refer either to the striations on them or else to the coupled ideograms of Chinese poetry,

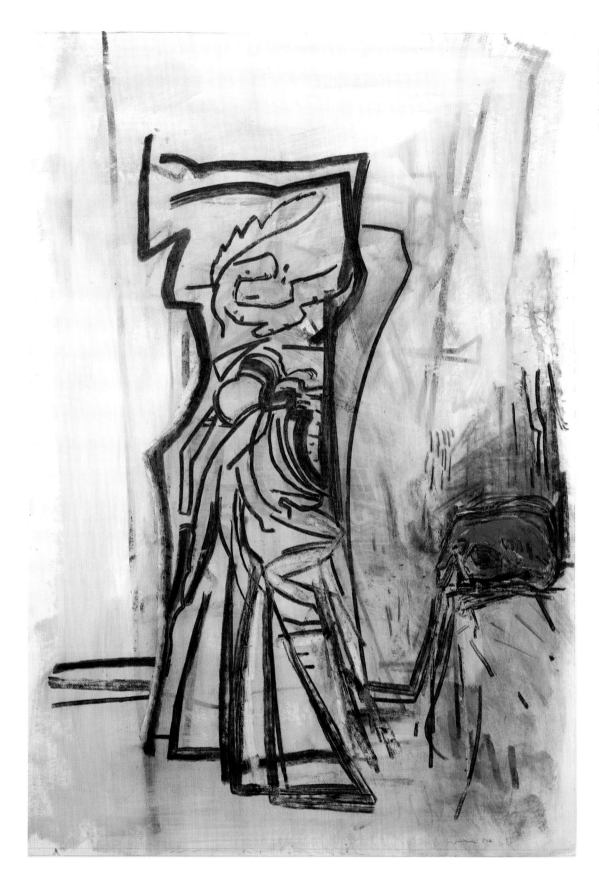

9 JOHN WALKER.
Untitled. 1984. Charcoal
and gesso on paper,
124.5 × 85.1 cm
(49 × 33$\frac{1}{2}$ in). Private
collection

10 JOSEPH BEUYS.
Swan Woman. 1958. Pencil
and watercolour (including
chloride), 29.6 × 20.7 cm
(11⁵/₈ × 8¹/₈ in). Private
collection

which move down the page vertically, balancing and affecting each other (Pl 11). An element of flux, if not a chance, is brought into these drawings by his use of long sticks dipped into ink – a particular way of not repeating himself.

Likewise, a drive to reclaim energy, in particular of the human presence, can be found in the drawings of John Walker. In a period from 1972 to 4, having made a reputation as an abstract painter, he found himself unable to paint and instead drew endlessly on a blackboard in his studio. (Yet again we find an artist in crisis going back to drawing.) After having had an entire wall painted black he would work with chalk, his large gestures related more to the extension of his complete arm on body, rather than just wrist or finger. With their scale and architectonics they were some of the most ambitious drawings of the period.

Even when Walker returned to painting, drawing remained a crucial practice. His drawings were done after, rather than as sketches for, his paintings. In them he expanded upon motifs uncovered in painting. As he said, 'the painting itself is the *motif* ... I have concluded that the drawing has become the conclusive statement, not the painting.' Drawings became meeting places for many things: the quasi-figures of his paintings, a Japanese-like sense of ornament, handwriting, a sense of the past, as when an old layer of drawing would be half covered up with gesso (Pl 9). His lines are at once architectonic, structural and – with their rich use of charcoal – sensual. Often one will catch in these long lines an echo of a human calf or arm.

In a famous article on the art of Cy Twombly Roland Barthes extols his sensitivity to things as facts, not the things represented, but the actuality: 'Twombly imposes his materials on us not as something which is going to serve some purpose, but as absolute matter, manifested in its glory (theological vocabulary tells us that the glory of God is the manifestation of his Being). The materials are the *materia prima*, as for the alchemists.' But this manifestation is not wrapped up in decorum or religiousity: the stuff drawing is made

with is crucial – as we will see with Beuys. Twombly's methods, dragging the pencil or crayon, scratching, smudging, smearing, scrawling, are unusual. As Barthes points out, 'these gestures, which aim to establish matter as fact, are all associated with making something dirty'. A dirty object has a history, associations, it has been touched. For Barthes, 'it is in a smear that we find the truth of redness; it is in a wobbly line that we find the truth of pencil. Ideas (in the Platonic sense of the word) are not metallic and shiny figures, in conceptual corsets, but rather shaky stains, on a vague background.'

If Johns or Marden work with a methodology of mark-making from which a poetry slowly emerges, Twombly aspires to a drawing style that is directly poetic, that is rapturous. It is like the difference between a fugue and a rhapsody. If a drawing by Johns, to use the metaphor from information science again, has a slow build up of aesthetic noise, one by Twombly seems to have nothing but such noise. We notice how sensitive the space has become around these trailed marks (this is true of much drawing today: Marden, Armando, Sultan). In part this is to do with the concentration involved in evoking particular things, and in part to do with a feel for the poetry of objects in the world, perhaps in part a contemporary sympathy for the Japanese tendency to see the spaces around the object rather than the object itself.

Just as Demosthenes, who with pebbles in his mouth to correct his stutter, practised oratory alone by the ocean, hurling his sentences across the waves so in these drawings Twombly's lines, which sometimes too turn to words, are hurled into and held in space. When he draws a word, 'imagine' or 'despair' it is to give it much the same articulation that a Shakespearean actor would give a key word, that else lies blank on the page: 'never' or 'tomorrow'. In a drawing such as that illustrated here from 1988 (Pl 5) there is a strange relationship between such heightened words and the nameless lumps and shapes – not only the wheel shape nearly covered with red crayon, but also the drift-

ing circles that frame the smaller sheet of paper. Do these marks act in the same way as sound clusters in modern music, floating around these scarcely decipherable lines as they would around a singer's voice?

Twombly is often characterized as an artist's artist: his work arouses either enthusiasm or bemusement. Of no artist is it more true to say that the best way to understand his work is to imitate it: like many others my appreciation of his drawings was subsequent to finding myself inadvertently trying to make a Twombly drawing – and finding myself signally lacking the ability to get it right.

The preceding five artists are primarily painters; it is more difficult to describe Joseph Beuys: sculptor, political activist, shaman, performance artist; to some a charlatan, to others a prophet. His production of drawings was vast and frequently exhibited, and it is perhaps his influence above all others that informs current practice in drawing.

His drawings have been described as models for rebirth, where tired things – an old envelope, a piece of faded graph paper – would be restored to life, their history given significance. His range of materials is bizarre: pencil, watercolour, iron chloride, silver, machine oil, fat and hare's blood. Such materials are essential for the evocation of those deeper forces, of that potential energy that his long looping lines feed on. Drawings were, for Beuys, doorways to a state where invisible forms could be seen: 'they attempt' he said, 'to get hold of that state, attempt to visualize how forces hang together, give shape to invisible configurations, but also as they relate to visible ones. This is something you can see in many different objects, a tree, say, or an animal running across a field. The observer says, Uh-huh, that looks like a deer, but there's something about the shape of this animal, something different within the surroundings, which, in the case of an animal now, is an attempt to describe its inner life and all the forces that are continually at work within it.' But such inner life is also wed to substantiality, hence the apparent fetishism of his obsession with materials, notably

12 JOSEPH BEUYS.
St. Elmo's Fire. 1962–71.
Watercolour, oil
(*braunkreuz*) and collage,
85.2 × 40 cm
(33$^{1}/_{2}$ × 15$^{3}/_{4}$ in). Private
collection

hare's blood and the ubiquitous heavy oil he used. Of this *braunkreuz* he said: 'What I'm trying to do with this brown is to link up with the idea of substantiality – not so much in terms of painting, more in terms of forming, of *feeling* substances.'

The *braunkreuz* drawing *Saint Elmo's Fire* (Pl 12) epitomizes the way drawing expresses the vitality of material. Saint Elmo's Fire is that phenomenon of corona discharge where in a storm electric light plays around the tops of masts on ships; to sailors it was seen as evidence that Saint Elmo was protecting them. More than that, drawing performs an act of alchemy here. Through it matter endlessly transforms itself. A similar transmutation can happen to the actual support material, as in the torn scrap of lined paper on which *Swan Woman* (Pl 10) is drawn.

This is an art that goes beyond connoisseurship. This is the drawing as a spiritual document. Indeed, when Beuys drew and wrote on blackboards, explaining his message, it was like a sermon. But the delicacy of the line is often extraordinary, as is his gentle persuasion of an image to the surface. What must be stressed is that for Beuys drawing was, firstly, a mediation between different forms and states of consciousness, secondly, an affirmative act. Anselm Kiefer writes: 'People think Beuy's work was dark, but this is to misunderstand it. He shows us the truth, which is one part of life. He gives us the truth to enjoy. His art is joyous.'

CONCEPTUAL ART & DRAWING: *BEYOND THE PAGE; BEYOND THE WALL*

*'My work has become a simple metaphor of life.
A figure walking down his road, making his mark.'*

<p align="right">RICHARD LONG (1982)</p>

Ten thousand straight lines at random. (1971)

Within a six foot square 500 vertical black lines, 500 horizontal yellow lines, 500 diagonal (left to right) blue lines, and 500 diagonal (right to left) red lines are drawn at random. (1970)

Lines, not short, not straight, crossing and touching, drawn at random, using four colours (yellow, black, red and blue) uniformly dispersed with maximum density covering the entire surface of the wall. (1971)

13 SOL LeWITT.
Drawing Project. 1968.
Private collection

Such were the instructions given by Sol LeWitt for three drawings to be made on various gallery walls (Pl 14). It was not necessary for the artist himself to complete the drawings for, LeWitt has noted, 'the idea becomes a machine that makes the art'. When LeWitt initiated the wall-drawings in 1968 he, or the draughtsmen employed, used 8H or 9H graphite sticks so that the drawing was an insubstantial shimmer on the wall. Effectively it was co-existent with the wall, creating no sense of depth. Nothing could be further from the abstract expressionist notion of the line as psychic writing or utterance. The beauty of this work was in its order, its coherence and lack of gratuitous rhetoric. Not that the personal or autographic was totally denied: a drawing would vary according to who actually completed it. With his tongue, one suspects, partly in his cheek, LeWitt described thus the relationship of the draughtsman to the execution of the instructions: 'The draughtsman and the wall enter a dialogue. The draughtsman becomes bored but later through this meaningless activity finds peace or misery. The lines on the wall are the residue of this process. Each line is as important as each other line. All of the lines become one thing. The viewer can see only lines on the wall. They are meaningless. This is art.'

For Alloway or Rose this re-introduced the contemplative and rationalizing function of drawing. In its repetition and humility this is not dissimilar to the spiritual exercises of many mystics. At the heart of such an art as LeWitt's or the early Mel Bochner's was the act of counting or working out permutations. The 1968 work from which began

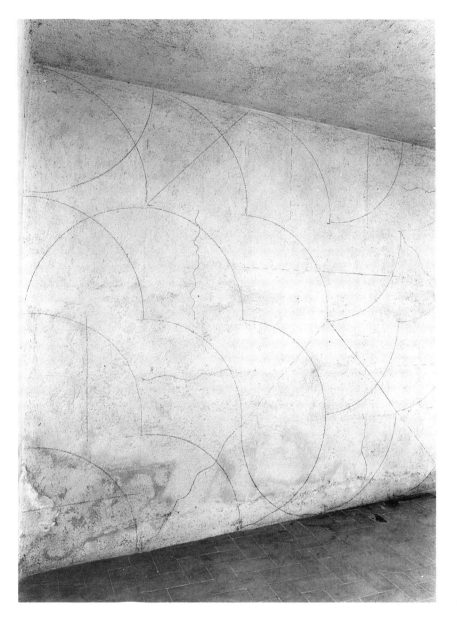

14 SOL LeWITT.
All Possible Crossing
Combinations of Arcs,
Straight Lines, Lines Not
Straight and Broken Lines.
(detail) 1972. Spoleto.
(draughtsmen: J. Taub, R.
Taub, L. Faten, R. di S.
Martino). Private collection

Though still not necessarily drawn by LeWitt himself, the instructions now seem to allow more variations and fluctuations in handling.

Richard Long has, in comparison, alway seen his personal relationship to the 'drawing surface' as crucial. His early work can be seen as drawing on the earth's surface with his body or feet. This remains true of all his subsequent walks. From the start of his career he has also traced on maps the paths he has walked: a pen repeating what his feet had done on a small scale. More recently he has taken to drawing on the wall, using mud from the River Avon (Pl 16). The Avon runs through his home town of Bristol and its mud has a personal significance for him. Sometimes, with a muddy hand, he will stamp concentric circles; sometimes he will scrawl with his fingers across bands of mud. The first method creates a hierarchic image redolent of a mandala; the second links back to gesturalism.

Michael Craig-Martin has written of Long's work that its essence lies, 'in its intensely emotional and physical evocation of the natural world. The essence of his aesthetic is in his ability to allow expression to surface through the means at his disposal. He does not make the stones and words and images speak, he lets them. He allows them their inherent power. There is no ego here, no cleverness, manipulation or distortion. It is as though the artist was at the disposal of his materials, not them at his.' In a work known only by a photograph, *Avon Gorge Water Drawing, Bristol 1983*, water poured down a rock face leaves a complex trail of dark marks to dry and disappear in the sun. Working thus is not so new or radical as may be thought: one recalls Duchamp's use of chance, falling strings determining lines to be cut or drawn, or Smithson allowing elements to flow or decay in his land art. What is different is Long's implied role as a conduit for nature to act through, though unlike Beuys, he avoids the role of shaman. This is true of his recent wall-drawings where muddy water is thrown at the gallery wall. Who is doing the drawing here as the mud splatters, runs in

these drawings was LeWitt's *Drawing Projects (Fours)*, later known as *Drawing Series I, II, III, IV*, where a square and four types of parallel line were run through all possible permutations (Pl 13).

LeWitt's wall-drawings of the eighties have been amongst the most ravishingly beautiful works of the decade (Pl 15). Made with coloured inks rather than graphite sticks or chalk they seem freer, with some vestigial illusionism and with some sense of the numinous – that there is something else more than marks on the wall.

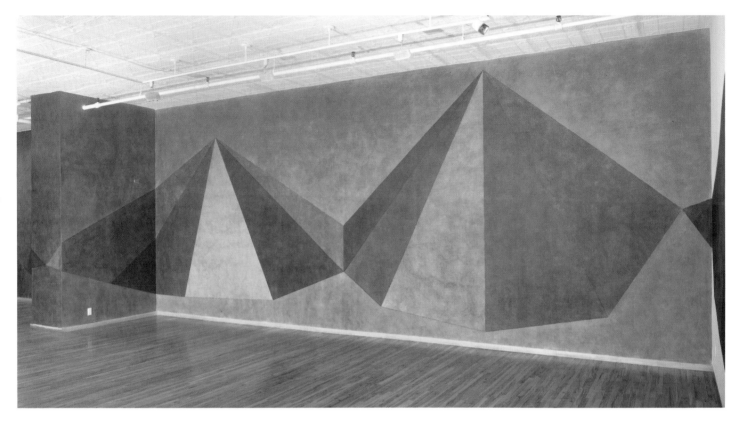

15 SOL LeWITT. *Multiple Pyramids*. 1987. Coloured inks. Installation at John Weber Gallery, New York

16 RICHARD LONG. *Untitled*. 1988. River Avon mud on paper, 50.8 × 39.1 cm (20 × 15³/₈ in). Private collection

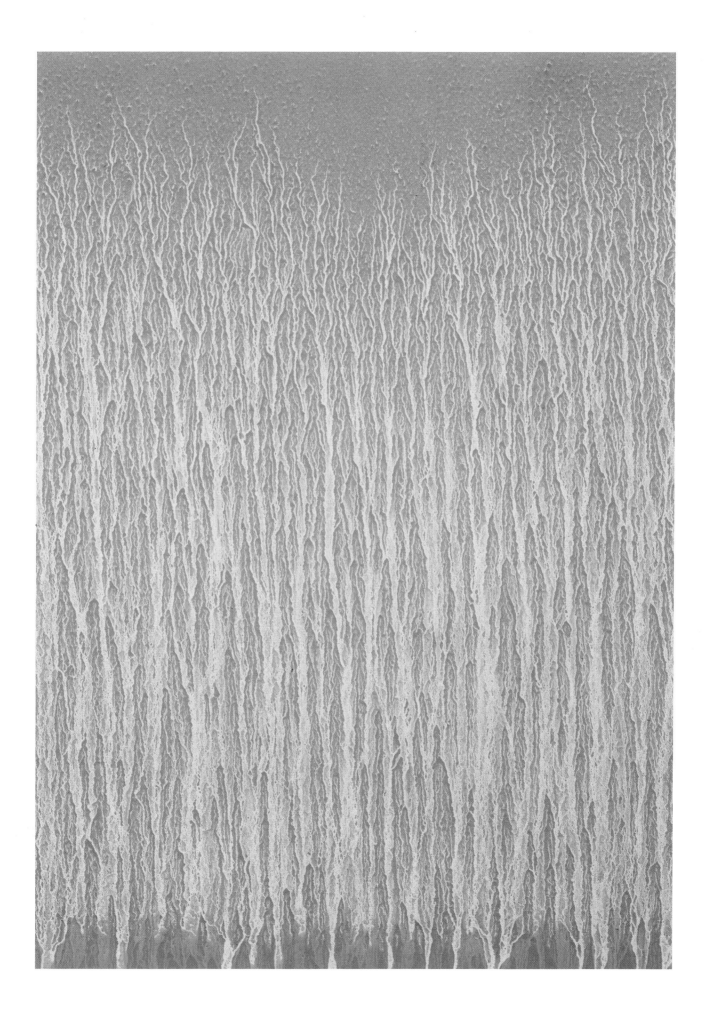

grainy rivulets down the wall and dries? The artist or nature?

Other artists have likewise sought to collaborate in drawing with nature's processes: in England Roger Ackling has used the sun's rays to burn lines into bits of wood; in Germany Herman de Vries has repeated Durer's drawings of grass with real grass and foliage. Like Long's Andy Goldsworthy's work is a dialogue with nature, but one in which he is prepared to manipulate things more playfully and more deliberately. Maple leaves will be stitched together to form a line that is floated out on water, broken pebbles will be placed so that the cracks draw a spiral, stones will be scratched with other stones to make flickering striations. Of a piece made in 1987 in Kiinagashima-Cho, Japan he writes, 'afternoon – ends pushed into bitten holes

to make screen – going dark – calm, warm, humid, raining, mosquitoes.' For a few hours a drawing made with broken bamboo sticks will stand, like a grandiose ideogram against sky and sea (Pl 19). (Though there may be some perversity in calling this a drawing when the artist himself calls it a sculpture, it does help draw attention to the way drawing extends into other media. Sculpture and painting have frequently involved a coherent element of drawing. The tradition of sculpture as drawing in air continues. A more curious use of drawing in sculpture is in recent wooden sculptures by Tony Cragg where an incessant pencil scrawling across different elements acts as a unifying element.)

Like many others Ian McKeever works in the landscape, but with very different philosophies

17 IAN McKEEVER. *Sand and Sea*. 1977. Graphite and photographs on paper, 99.1 × 55.9 cm (39 × 22 in). Collection the artist

(*overleaf*)
19 ANDY GOLDSWORTHY. *Kiinagashima-Cho, Japan. 27th November.* 1987. Morning/woven bamboo/ afternoon/ends pushed into bitten/holes to make screen/going dark/calm, warm, humid, raining,/ mosquitoes

and practices to Long or Goldsworthy. He is intent to go to the landscape, but not as an innocent giving himself up to nature; rather he is at once critically aware of how nature is mediated by representation and concerned that his work should register both the effect of these various mechanisms of representation and his involvment in the processes of the natural world. His early work such as the *Sand and Sea* series (Pl 17) were almost schematic in their presentations of drawing and photography as different ways of registering marks. He wrote in 1978 that, 'drawing and photography are like landscape in that they are able both to expose and obscure, reveal and conceal . . . they are like the agents of land erosion breaking down and rebuilding surfaces.' But, as he increasingly used it, photography became that other against which drawing must pit itself. Photography is closed, drawing open; photography is illusory in its completeness, drawing as unfinished as nature itself. He uses the term 'noise' in its scientific sense to explain how a drawing works: 'Drawing is a noisy process . . . noise is information lost in the process of translation: a residue which will not change state and cannot be re-organized. In the case of drawing residue occurs as the process moves through action, onto mark and representation. The order inherent in the drawing always edges towards chaos.'

His journeys have been to where the landscape is, in mark-making terms, noisiest, where sea and rock struggle against each other, where geological change is most evident, where drawing on its grandest scale is in process. There, be it in an Essex field, Lapland or the Scottish Isles, he draws intensively, making rapid drawings as well as taking photographs. These are re-combined in studio works where the enlarged and often battered photograph is worked over with marks to register a more physical response (Pl 18). It is crucial to realize that he sees the world as a set of processes rather than as a set order. Drawing too is a set of processes. The belief that the world is in flux has a long history, from Heraclitus who believed that fire

underlies all things, to twentieth-century atomic theories. How one defines drawing to a great extent depends upon whether one sees marks as replicating, or even embodying, this state of flux or else delineating something ideal and unchanging. At question is where one believes energy to come from. There is a drive in much recent drawing to get back to the underlying source of energy: this is to be found in animals and fetishistic materials for Beuys, in concepts for LeWitt, in culturally loaded

18 IAN McKEEVER. *Staffa – Untitled*. 1985. Pencil and photograph on paper, 76.2 × 55.9 cm (30 × 22 in). Collection the artist

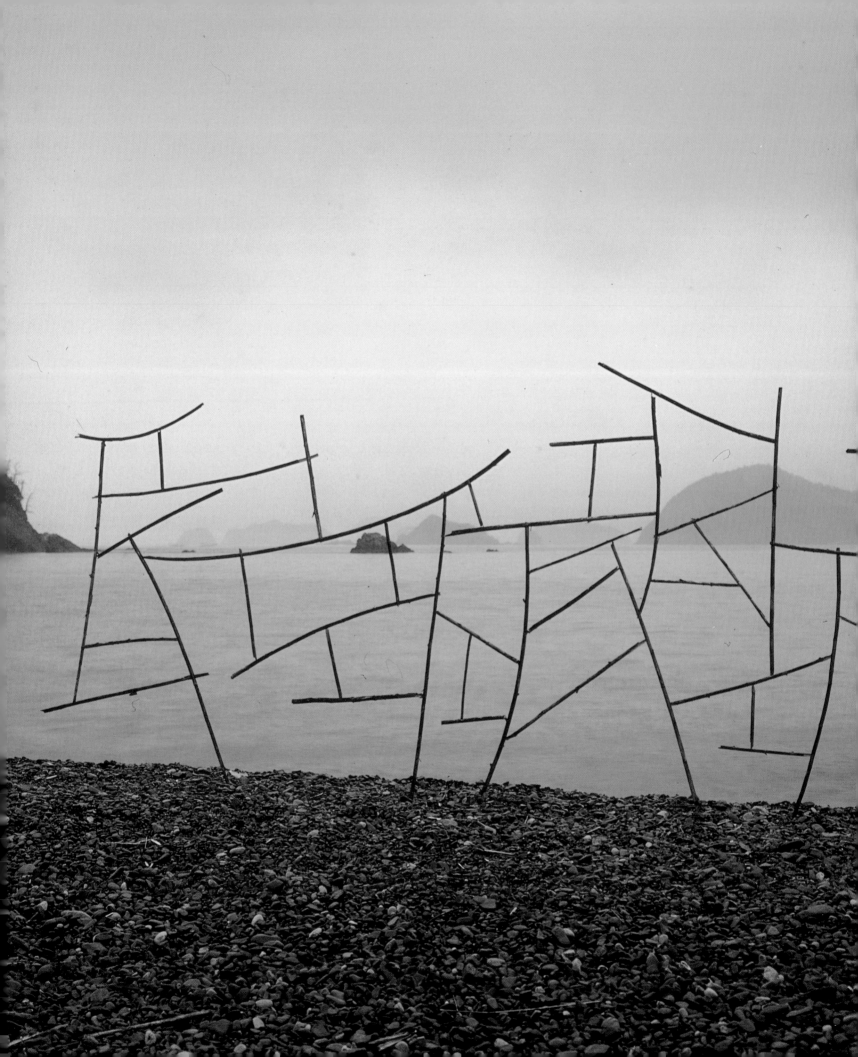

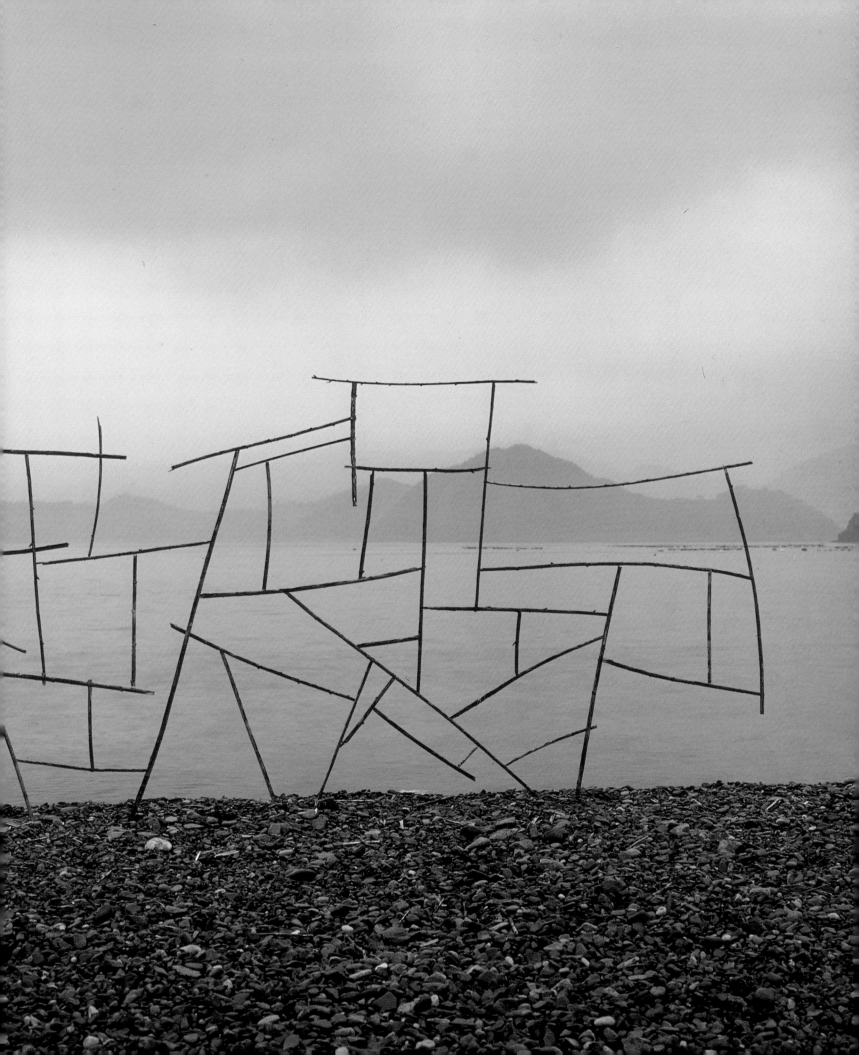

20 ARMANDO.
Guilty Landscape. 1975.
Pencil and photograph,
both 100 × 75 cm
(39$\frac{1}{2}$ × 29$\frac{1}{2}$ in). Private
collection

images for Walker. McKeever is one of the closest to hylozoism, the doctrine that all matter has life or energy. It is evident that Nature means something very different to him than Nature does for Richard Long. Mark-making, and hence drawing, are determined by such beliefs.

It is not coincidental that his working methods at times echo those of nineteenth-century explorers, not only in their concern with observation, but also in the rigour of working in a place like Greenland, where his watercolours froze on the paper and his hands were too cold to hold a pencil for long. In the drawing shown here done in Greenland abstraction and representation jangle together, the drawn shape of a glacier meshing with an effulgence of watercolour (Pl 22).

The Dutch artist Armando likewise sometimes splinters photographs with drawing. He too has a hatred of compositions, of things that have become too pat. For the *Guilty Landscape* drawings of 1972–4 (Pl 20) he reproduced photographs of landscapes where terrible events had occurred, above all else near Amersfoort concentration camp, not far from where he was brought up – 'a place petrified in guilt and shame'. The landscape is guilty because it is unaffected by what has happeed in it. He describes such drawings as 'psychogrammes' for he says, 'what do I add to the photograph? I draw. And what do I mean by the drawing? In a way it is a means of "*Bewaltigung der Vergangenheit*", of overcoming, attacking the past. At the same time, of course, one knows perfectly well that one can never overcome the past.'

The lines are few, terse, jerky and stuttering (Pl 21) – the opposite of the fluid lines the fine art academies extolled. What Armando strives for is

21 ARMANDO. *Untitled*. 1984. Pencil on paper, 51 × 73 cm (20 × 28³/₄ in). Private collection

(*opposite*)
22 IAN McKEEVER. *Untitled – G.9, 1988*. Pencil and watercolour on paper, 23 × 17.5 cm (9 × 6⁵/₆ in). Collection the artist

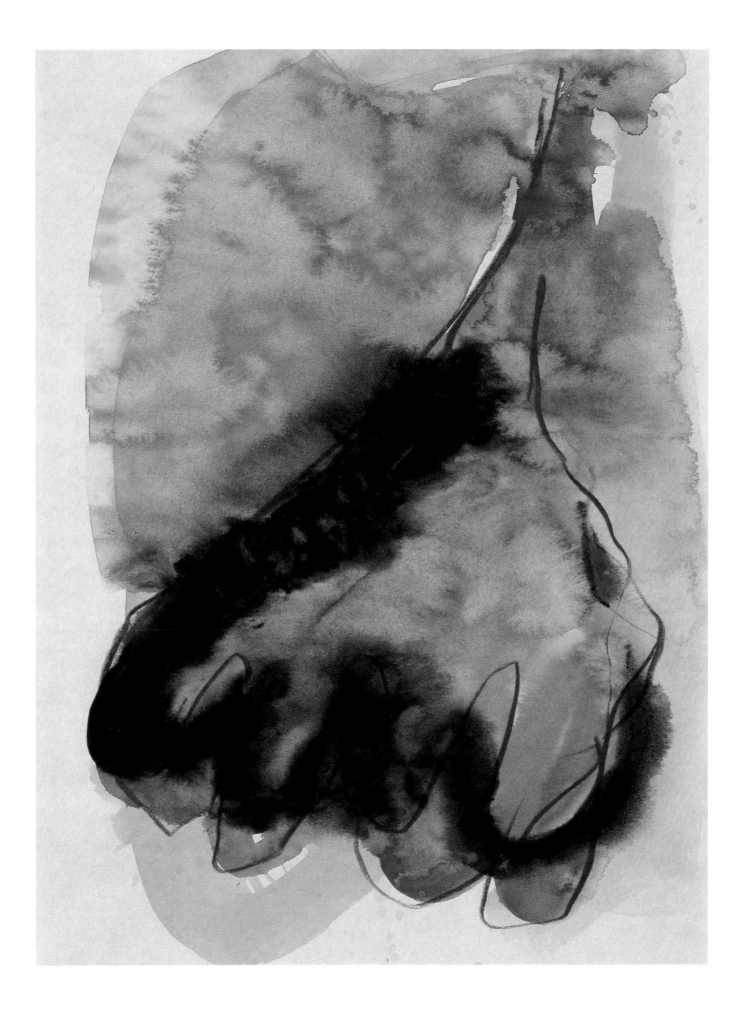

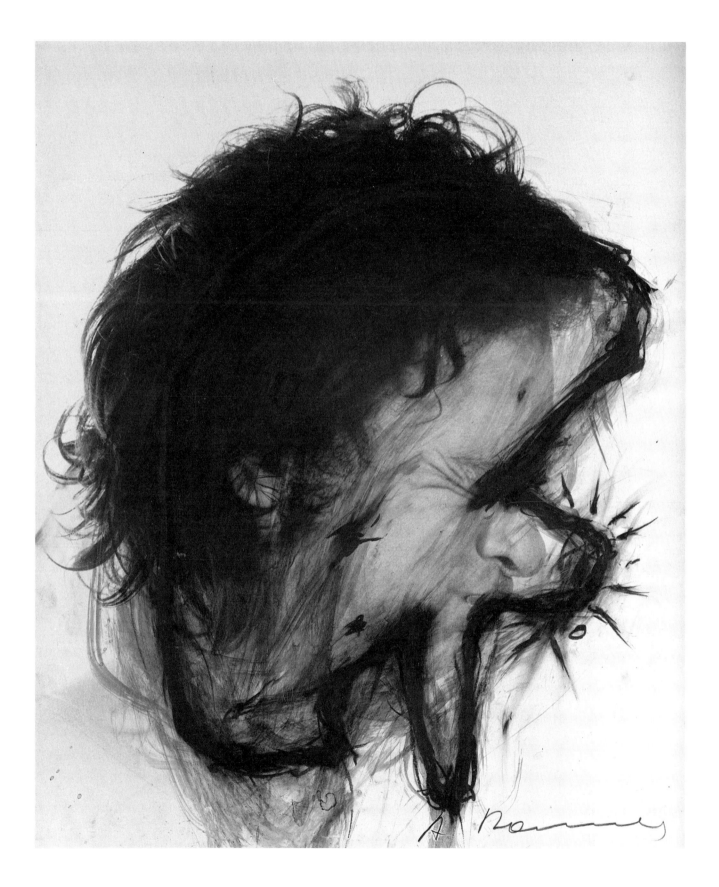

23 ARNULF RAINER.
Untitled. 1969/72. Oil
crayon and ink on paper,
60.7 × 50.4 cm
(23⁵/₆ × 19⁵/₆ in). Private
collection

the tension one finds in the drawings of children. Like the scratching needle on a seismograph they register discontinuities, excitations, threats. Like cracks or crevices in the skin or in the drying of the earth they register tension. The lines here, or in his pure drawings, brace themselves against the open space of the paper.

The overpainted or overdrawn photographs he made between 1969 and 1974 remain Arnulf Rainer's most potent work. The photographs, such as the example here of his own face (Pl 23), show body language at its most extreme, but as the photo deadens things out so slashes of paint, crayon or ink can restore the potency of his 'histrionic gestures'. He had been interested in disfigurement since 1954 when he began drawing over old drawings. Rainer's residing belief was in the necessity of the art of the insane, whose unknown meanings and expressions must be brought into normal discourse – a parallel to his involvement in compaigns to bring the mentally ill into the community.

In these photo-drawings lines crackle and spit, jabbing into or sliding over the contorted face. He began making such works when experimenting with mescalin (as did Henri Michaux in making the quintessential automatic drawings of the fifties), but later developed the ability to create such psychic states without artificial stimulants. With customary paradox he has written, 'I had the feeling that I was creating accentuated self-reproduction, but also at the same time causing symbolic changes and developing forms of self-destruction. Thus self-portraits, an eternal desire of all artists, gave me the opportunity to find anti-social inner structures and to uncover the "*unter-mensch*" within me and use them to create socially acceptable and sellable products.'

Graffiti or disfiguration can be an attack on society and its norms, just as it is in the more sophisticated work of Rainer. The same may be said of Susan Hiller's wallpaper works where wallpaper loaded with repellent kitsch (doe-eyed girls, action men, Masters of the Universe) is drawn over (Pl 24).

In 1972 Hiller was involved in an automatic writing project as a result of which she began to write and draw as though not herself (not in her normal handwriting). Undercutting such writing/drawing, which when decodable was cryptic, is a doubt as to identity; as she wrote, 'this activity, that could be viewed as evidence of some "primitive" urge to self-expression, or as some sort of "occult" phenomenon . . . addresses itself to the question it poses: "Who is this one?" . . . simultaneously participant and spectator, author and reader, singular and plural, "I" feel more like a series of activities than an impermeable, corporeal unit . . .' The over-drawing on the wallpaper is traced from a photographic negative of similar automatic drawing: the callous and calculated fantasies of the mass media are confronted by drawing at its most private and mysterious, replete with sensuality and a sense of the intuitive archetypal.

Some of Hiller's work confronts sexual stereotypes as, in a more playful way, did some work of the mid-seventies by Annette Messager where she drew upon her own body, subverting stereotypes. A spider crawls over her, she reacts in mock horror; a face is drawn on her stomach, its beard her own pubic hair. Considering that flesh is one of the oldest supports for drawing it is curious that its use in recent art has been so occasional. Francesco Clemente has noted how Céline as a doctor drew lines on his cadavers: what could be more uncanny than this convocation of the dead and the figuring mark of the living?

Many twentieth-century thinkers (Wittgenstein, Benjamin, Barthes, Foucault) have been concerned with how we perceive and represent things, including ourselves as objects. Conceptual art, and all that heterogenous body of work that has been influenced by it in the subsequent twenty years has extended that obsession. The Swiss artist Markus Raetz has been fascinated by the endless transforming power of drawing, often showing large series of related drawings together in which the meaning changes as quickly as a sleight of hand (Pl 26). Often his crisp, elegant drawings present

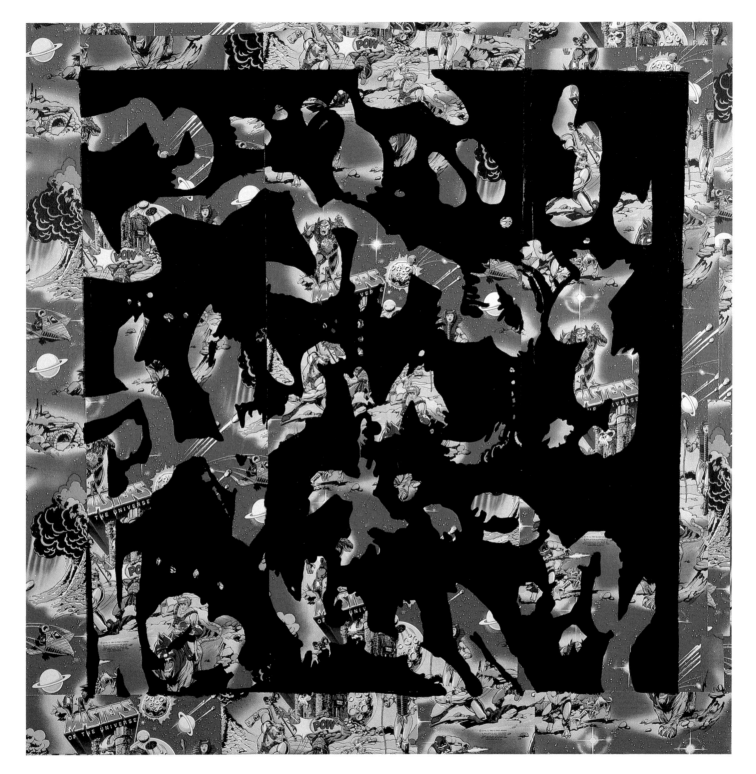

24 SUSAN HILLER. *Masters of the Universe, 1986.* Ripolin on wallpaper on canvas, 144.8 × 144.8 cm (57 × 57 in). Private collection

25 EDWARD ALLINGTON. *The Source*. 1986. Ink and emulsion on paper, 32 × 40.5 cm (12½ × 16 in). Private collection

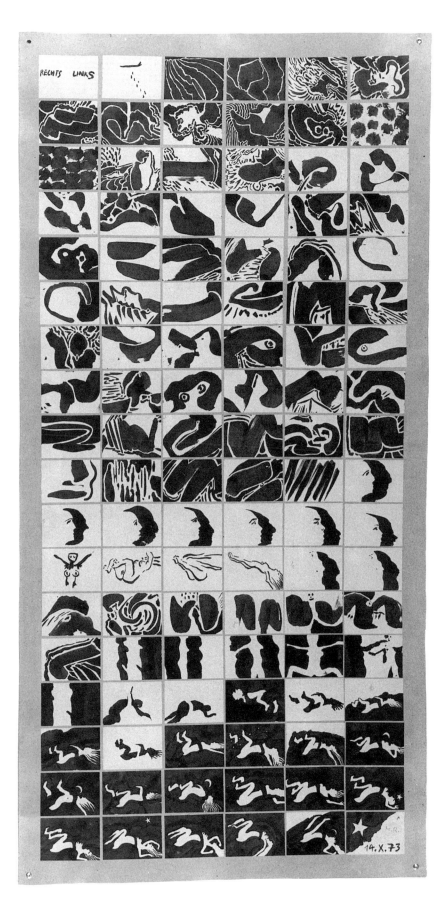

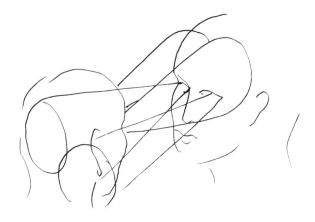

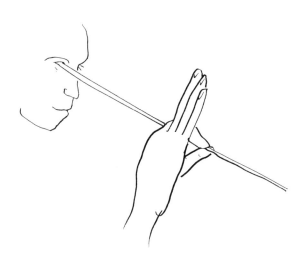

an allegory of drawing and seeing: a hand draws a face that looks back at the draughtsman (Pl 27), a figure pinches a beam of light that issues from his eye (Pl 29), in one frequently reiterated image two arms enter through the eye sockets and cradle a ball inside the head – or, alternatively they can be seen as beams of vision issuing from the brain (Pl 28). A frequent conceit of his is on how we are linked to this material world by an umbilical cord that is formed mutually by sight and the drawn line. Other sequences of drawings play with notions of negative and positive, with building images from blots or chance marks. Often both the act of seeing and the pencil lines become synonymous with sexual desire.

In the eighties Raetz extended these inventions to anamorphic 'drawings' in the real world: what appear to be a few sticks, from the correct angle resolve into faces or bodies of monumental proportions. In the gallery such anamorphic images are constructed with eucalyptus twigs.

This play with illusion and the underpinning motif of desire is common to the work of Edward Allington. His drawings are normally made on pages from old ledger books so that his hovering forms are set against old handwritten records. Ornamental forms bundle into quasi-figures that pose or fly above their own shadows: shadows which in their blackness are like deep pools. Doorways and blanked-out walls create the illusion of a room – perhaps a metaphor for the mind itself. In this mental space fly or float scrolls, urns, geometric forms (Pl 25).

It has been suggested that ornament liberated thus, as in the most extreme rococo work, is an unleashing of the erotic impulse. This would seem to be true of Allington who believes we must return to a more Dionysian notion of form. Such an attempt to recover an active, Dionysian classicism is extended in installation works where sculpture and massive drawings are combined (Pl 30). Two key influences on Allington have been Hogarth's plates to the *Analysis of Beauty* and Piranesi's prints of ruins, both of which conjoin heteroge-

31 BRUCE NAUMAN. *Sex and Death*. 1985. Neon and glass tubing mounted on aluminium (black) 182.9 × 243.8 × 29.2 cm (6 ft × 8 ft × 11 1/2 in).
Private collection

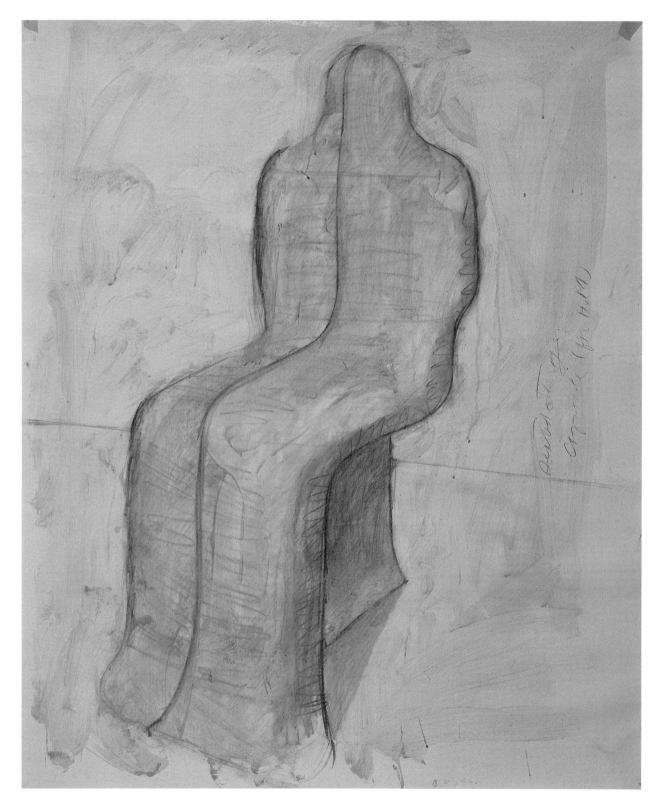

32 BRUCE NAUMAN. *Drawing for Seated Storage Capsule for Henry Moore*. 1966. Pastel and acrylic on paper, 106.7 × 90.8 cm (42 × 35³/₄ in). Private collection

nous objects with a witty and sensual use of line. It may be noted here that, as for Beuys, LeWitt, Morris or Trockel – all of whom could be termed sculptors – drawing is not preparation for sculpture, but a parallel activity of equal importance.

Since 1965 Bruce Nauman has made sculptures in various media: photographs, installations, films, videotapes, neon-light reliefs. Beneath his freewheeling attitude to media drawing is a persistent and underpinning thread. His drawings, which vary greatly in style, are ostensibly plans or blueprints for objects or installations, yet their facture gives them an implicit degree of aesthetic 'noise' – just as a meal meant to sustain your body also affects your sense of smell and taste. The *Drawing for Rotating Glass Walls* (Pl 33) has with its *pentimenti* and seeming mistakes an emotional urgency to its conceptualizing far different from LeWitt's drawings of the same period. A *Seated Storage Capsule for Henry Moore* (Pl 32) is both a pointed deflation of the pretensions of the late Moore

sculptures with their 'humanity' and 'spirituality' – his archetypal shape degraded into something like a typewriter cover – and a strangely beautiful drawing. Nauman's neon reliefs (Pl 31), of flashing punning words, or scenes of violent interchange, may be seen as a logical extension of drawing on paper into drawing with light on the wall – or in the darkness. Despite the vulgarity normally attached to neon and the nastiness of Nauman's subject matter there is a surprisingly hierarchic feel to them.

Coolness, if not the hierarchic, is to be found in the drawings of both Ed Ruscha and Robert Longo, each of whom, in different ways, keeps the overtly autographic out of their art. Longo does so by meticulous technical drawing (not always by himself), Ruscha by spraying the pigment onto the paper. In Longo's drawing his method emphasizes both the monumentality of the over life-size figures (Pl 34) and the alienation of the city figures *in extremis* (in fact they are copied from photo-

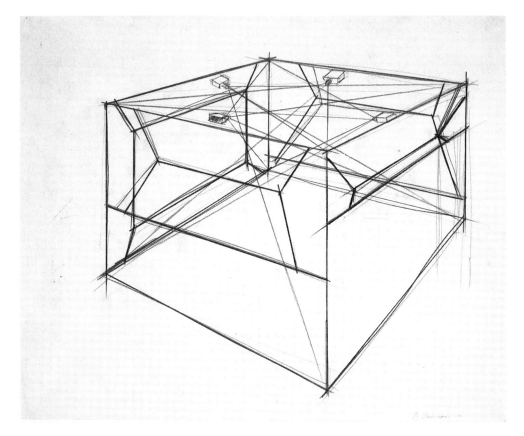

33 BRUCE NAUMAN. *Drawing for Rotating Glass Walls*. 1970. Pencil, coloured pencil and felt-tipped pen on paper, 58.5 × 73.8 cm (23 × 29 in). Collection Basle, Offentliche Kunstsammlung

34 ROBERT LONGO.
Untitled. 1980. Charcoal
and graphite on paper
274.3 × 152.4 cm
(108 × 60 in). Private
collection

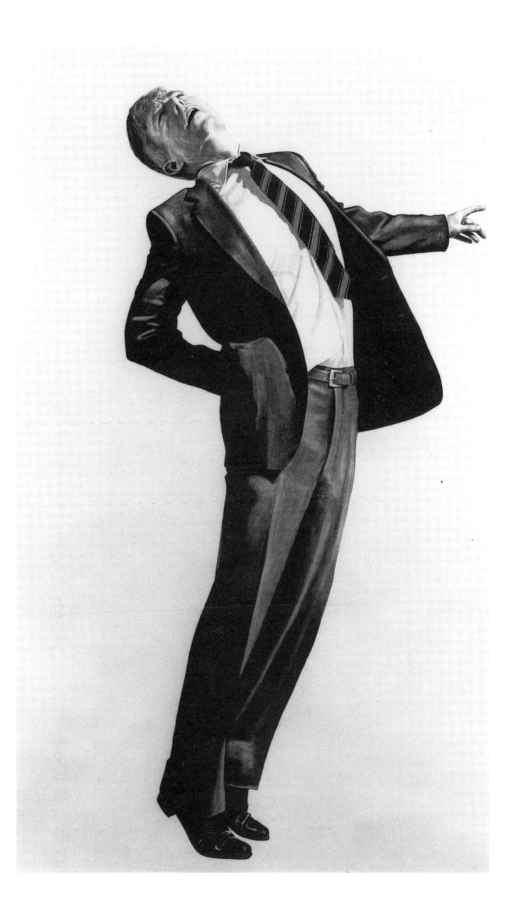

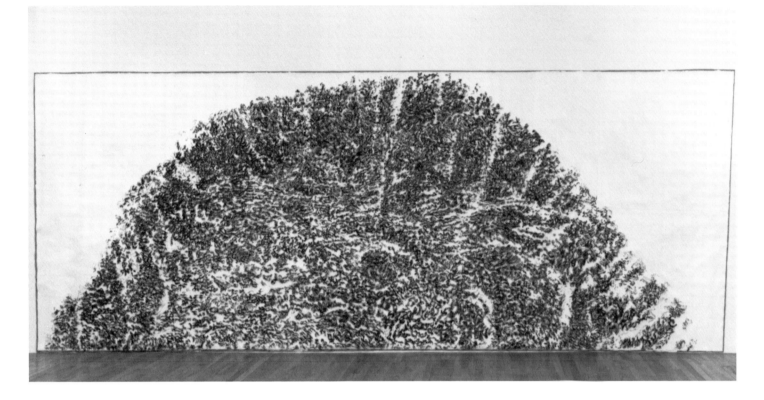

graphs of people jumping in the air and falling down again). Rucha's work is less chilling, more amiable in its quizzical undercutting (through method, interpenetrating motto and sheer beauty) of the clichaic nature of its model (Pl 36).

If Ruscha and Longo use drawing to rehearse presentations' of alienation and of the ironic, Giuseppe Penone uses drawing as a tool to restore contact with the world. Since 1974 he has been making *pressione* drawings: an area of the skin is put against a receptive surface, the imprint photographed and then projected onto a large wall; graphite sticks trace the outlines and surface markings (Pl 35). This is both a homage and demonstration of the sense of touch. The touching membrane (skin) is magnified from a microcosm to the scale of a giant map; the making of it, with the graphite jumping and pushing on the wall with its irregularities, is deliberately ostensible. To Penone drawing is a matter of seeing with the hand and a way of recording the kinetic sensation of the eye by touch.

Not only interior walls, but also walls of the street outside can be utilized in drawing. In 1980 life-size figures began to loom ominously in parking lots and back streets throughout America and Europe (Pl 37). Some still survive, though often peppered with graffiti. These 'shadowmen', the work of Richard Hambleton, may be seen as a curious variation on the Corinthian maid's drawing. As drawings they at once intruded on the life of the street, and as unmoving figures stood like witnesses to it. The life-size figures he made at the same time in the studio show more clearly their origin in gestural abstraction. If we recall what Beuys said about drawing getting hold of some inner form in animals we may see these drawings as being of some inner dynamism of the person. The dance-like performance with which they were made (violent slashes and twirls of arm and body, pursuing a stroke as though bowling a ball, or tearing at something) echoes through the figure which, with its splatters and swirls, is like a hieroglyph unleashed (Pl 38).

35 GUISEPPE PENONE. *Lip.* 1982. Charcoal on paper mounted on paper and linen, 233.7 × 598.2 cm (92 × 235 1/2 in). Private collection

36 EDWARD RUSCHA.
Brave Men Run in My Family. 1988. Pigment on paper, 152.4 × 102.2 cm (60 × 40 in). Collection Richard Salmon

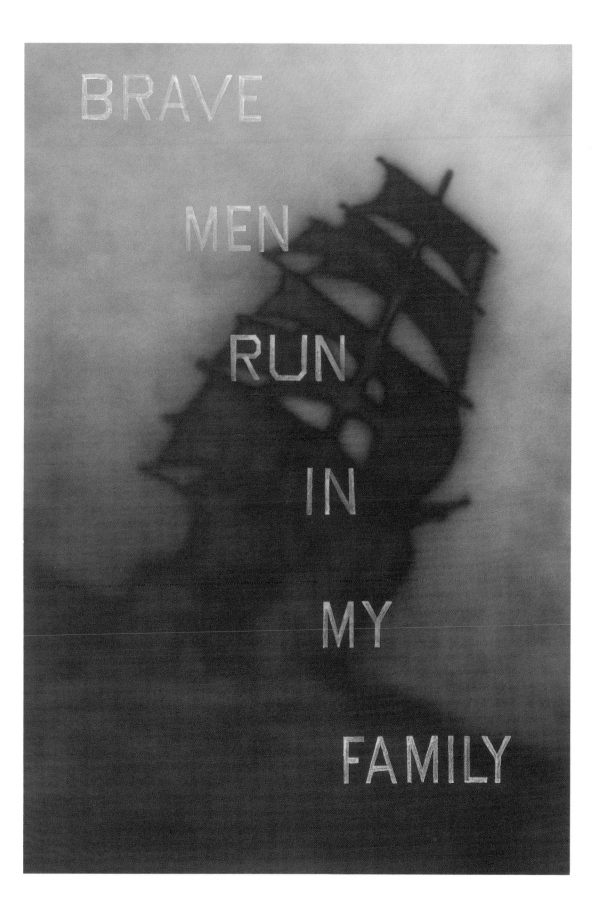

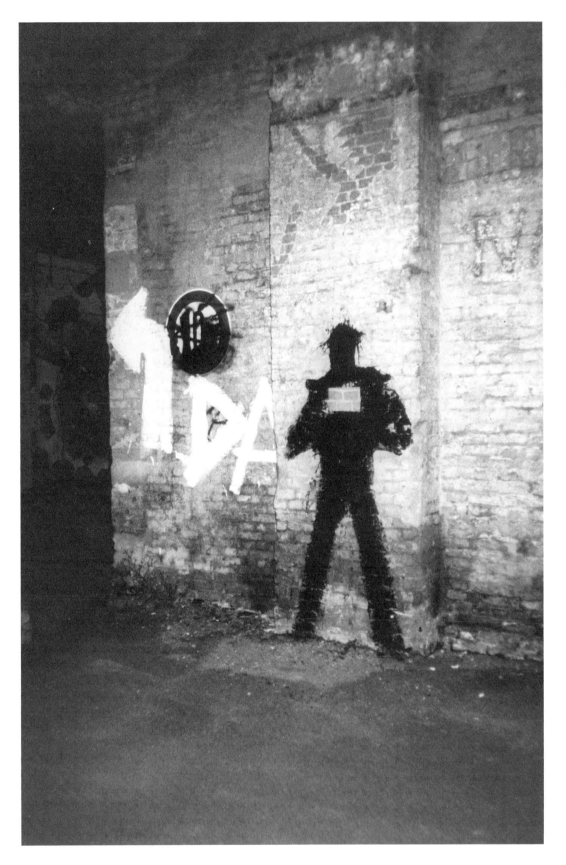

37 RICHARD HAMBLETON. *Untitled*. 1982. Black water paint on wall. New York City.

38 RICHARD
HAMBLETON. *Osaka*.
1981. Acrylic on paper,
193 × 127 cm (76 × 50 in).
Private collection

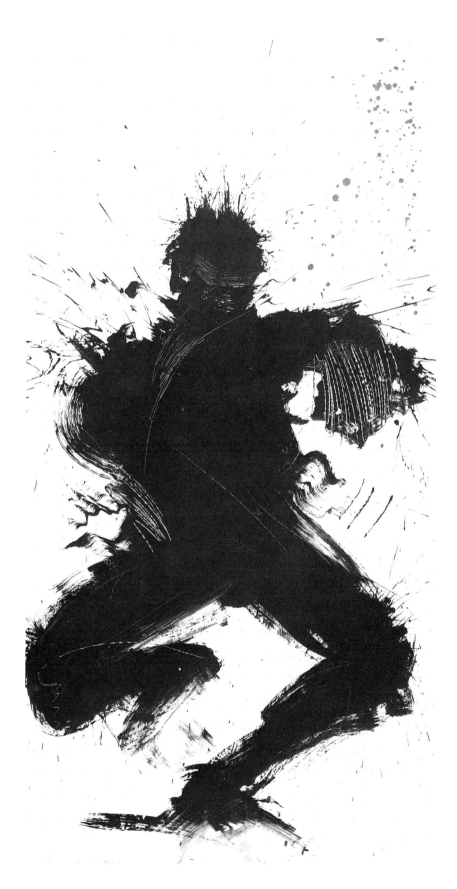

39 JONATHAN BOROFSKY. *Page from My Notebook*. 1979. Ink on paper, 19.7 × 12.7 cm (7³/₄ × 5 in). Private collection

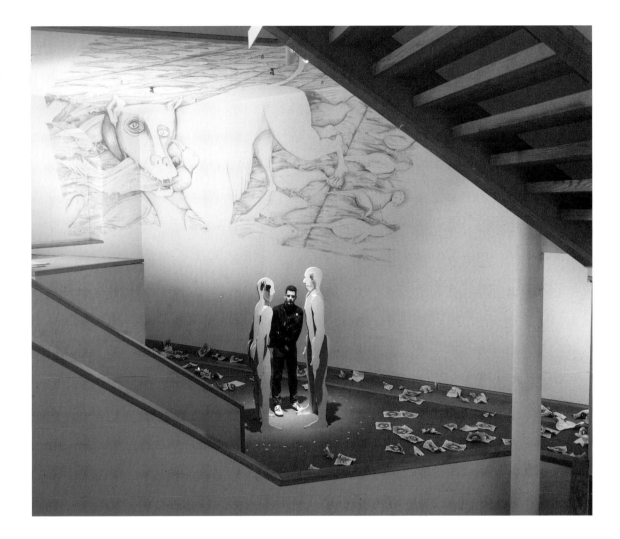

40 JONATHAN
BOROFSKY. Installation
view *Currents*. 1983–4.
Institute of Contemporary
Arts, Boston

On the Berlin wall (where Hambleton was sub-sequently to draw a line of shadow men) in 1982 appeared a large drawing of a running man. Underneath was the enigmatic number 2511898. As though in fear his head is turned to the viewer. The work of Jonathan Borofsky the drawing was too deliberate, too coherent to be confused with the sprawl of graffiti and slogans that covers the wall like a scabrous wallpaper. This running man intervened into both the public space and the pri-vate imagination, but with less mystery, less menace than Hambleton's.

For some years up to 1972 Borofsky had been involved in purely cerebal art activities, above all else in counting. Beginning at one he had covered reams of paper with consecutive numbers; by the time he got to around 2,000,000 he felt, as he writes, 'the occasional need to scribble on the same sheet of paper as the counting. It was like taking a break. The counting had become a break from my thought process, and the scribbling now became a break from the counting. I would start moving the pencil around and making forms. Then I started making stick figures, and the stick figures doing different things. There were heads, and heads tied to trees.'

The counting continued but was now normally attached to drawing (hence 2511898) or objects generated from the drawing. The drawings refer to his dreams or passing thoughts, working very much like pages of a diary (Pl 39). In each exhi-bition the most recent clutch of drawings is

included, whilst a few key images are projected and redrawn on the wall or ceiling on a vast scale. As installations they tend to surround the viewer like the exposed chatter of his mind – in the installation shown here the two wooden men monotonously chant, 'chatter, chatter, chatter' (Pl 40). Figures such as the dog-like creature with a bird in its mouth or the running man in other installations recur and are both self-portraits and archetypes for the viewer to identify with. The experience of time, just as it underlay the counting pieces, underlies these drawings with their diary-like status. An aspect, indeed, of all conceptually informed work is thus to emphasize the process of drawing and the way it demonstrates our experience of being in time.

4 THE LIFE ROOM:
BACK IN THE CONFESSIONAL

'The single human figure is a swell thing to draw.'

R.B. KITAJ

In 1976 the American painter R.B. Kitaj, who has long been domiciled in London, selected a show of figurative paintings and drawings entitled *The Human Clay*. His catalogue introduction was an impassioned appeal for an art based on drawing the human figure. Such a way of making art, he argued, could *not* be outmoded: 'It's not as if an instinct which lies in the race of men from way before Sassetta and Giotto has run its course. It won't. Don't listen to the fools who say that pictures of people can be of no consequence...' Modernism anyway, he pointed out, had at its best (Picasso, Matisse, even Brancusi) been based on the human form – even Mondrian had trained by drawing the figure. The figure presented the real yardstick to judge oneself against: 'The single human figure is a swell thing to draw. It seems to be almost impossible to do it as well as maybe half a dozen blokes have in the past. I'm talking about skill and imagination that can be seen to be done. It is, to my way of thinking and in my own experience, the most difficult thing to do really well in the whole art. You don't have to believe me. It is there that the artist truly "shows his hand" for me.'

'Showing his hand' had two principal meanings here: firstly, showing a skill that could be generally appreciated (Kitaj was also calling for a more social and popular art); secondly, showing aspects of one's personality and desires. In subsequent interviews he expanded on these points, emphasizing that we were already in a tradition: 'The notion of a return to the figure is just media-talk. For some of us it's the only art we know.' Drawing and moral purpose are intimately linked here, in the same interview in 1977 he noted: 'I have been returning,

for the last few years now, in a very serious way to drawing. I will probably spend all the next year doing just that, probably doing nothing but drawing the single figure. These are my critical years. Jimmy Carter and I are born again.'

If Kitaj can seriously be said to have been reborn again it happened in 1974 when he visited the *Petit Palais* in Paris and saw Degas' pastels. Disaffected with his previous work (he had made his reputation as a pop artist using collagist techniques) he was staying in Paris with David Hockney who was himself out of sorts with his painting. Both set out on a course of intensive life-drawing, and in Kitaj's case also on an attempt to reclaim pastel as a medium for serious art.

Like all converts they were vociferous in their new faith: hence *The Human Clay* and several fractious interviews. The most curious manifestation was in an issue of the *New Review*, a now defunct literary magazine, where in addition to discussing the 'return to the figure' they both posed on the cover in full frontal nudity (this issue is now very rare, every library in London seems to have had it stolen!). It was indicative of the candor involved in the project; a candor similarly shown in the 1975 pastel *His Hour* (Pl 41) where issues of eroticism and voyeurism were met head on. A substantial group of pastels made from 1980 on are more straightforward as narratives (there is nothing as strange as the enveloping chair of *His Hour*), and more considered as structures, a strong architecture offsetting the sensual handling of the medium. They may be the most assured and successful pastels made by anyone in recent years. If his pastels and drawings at times slip into the sentimental it is an inevitable danger, for this is a

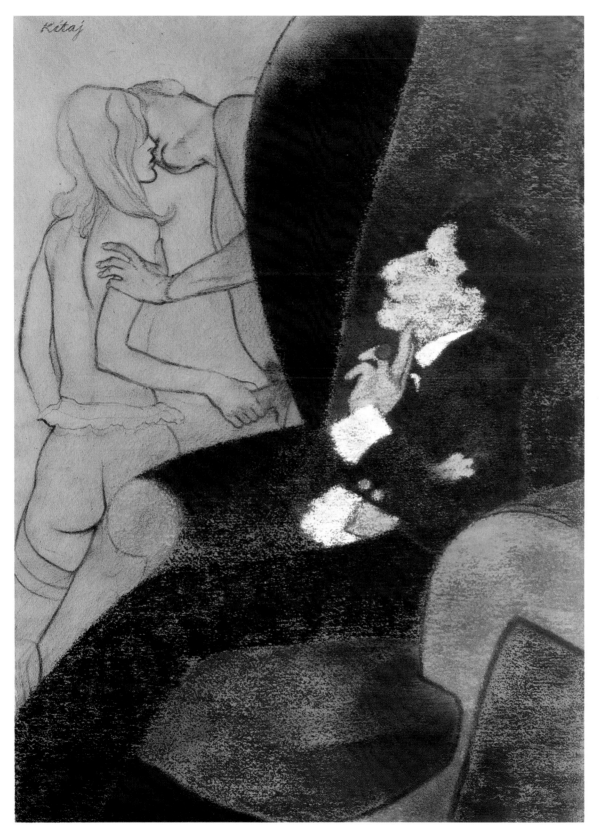

41 R.B. KITAJ.
His Hour. 1975. Pastel and
charcoal on paper,
77.5 × 57.2 cm
(30^1/$_2$ × 22^1/$_2$ in). Private
collection, Los Angeles

42 R.B. KITAJ.
Degas. 1987. Pastel and
charcoal on paper,
77.5 × 57.2 cm
(30½ × 22½ in). Private
collection, London

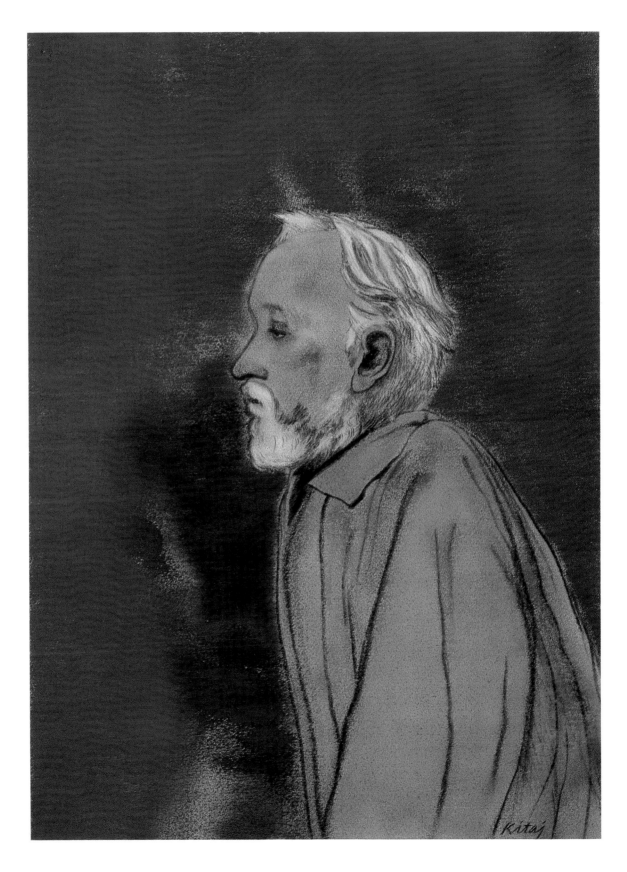

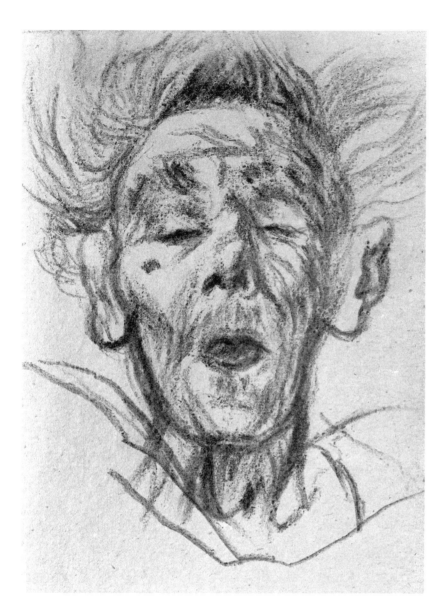

our, like his earlier, more collaged work.

Whatever the future direction of Kitaj's art he can, when skill and passion meet, produce extraordinary drawings, like that of his grandmother at 102 (Pl 43), where not only is the drawing of an old, lined and dissolving face, but apparently at the same time of an explosion and of a flower expanding.

As with Beuys, Hockney's life and opinions have been so frequently written of elsewhere as to scarcely justify rehearsing them again here. Sufficient it is to draw attention to the way in earlier drawings he created manifold possibilities with single taut lines (Pl 44); secondly, to the way he managed in drawings of the seventies to suggest sensuous experience (Pl 45); thirdly, how in this decade he has shown his inverterate modernism in his pursuit of style and the mechanisms of representation (Pl 46). His use of the photocopier as a tool to draw with may not appeal to his many admirers, but it shows the extent to which drawing remains for him an experimental medium. Such shifts can best be seen by examining the portraits made of a frequent sitter, such as Celia Birtwell. It is curious to note that Hockney is one of few artists to be overtly influenced by Picasso, who, we may remember, was drawing furiously and brilliantly up until his death in 1973.

Kitaj's great hope as expressed in the introduction to *The Human Clay* was to draw attention to a 'School of London', a group of artists working from the figure, in the great tradition, who saw themselves as above art fashions. More than a decade on one must note, firstly that life drawing is even less practised now in English art schools and that secondly no younger artists of any consequence have followed them (Kitaj is now fifty-seven, Hockney fifty-two. Of other artists in the exhibition Lucian Freud is sixty-seven, Frank Auerbach fifty-eight, Leonard McComb fifty-nine).

Akin to Kitaj in many respects is the Israeli Avigdor Arikha. (An interesting question is, 'why are so many figurative artists of Jewish descent? Is it because of an especial need to guard the liberal humanist tradition? Or a greater sense of the

43 R.B. KITAJ. *Grandmother Kitaj, aged 102*. 1983. Charcoal on paper, 19.7 × 14.6 cm (17³/₄ × 5³/₄ in). Private collection

risk-taking venture. It is a strength in his art that he is prepared to be embarrassing: what is embarrassment compared to the ambition of his project? '... not only to do Cezanne and Degas over again after Surrealism, but after Auschwitz, after Gulag (*et al.*). Some of us need a post-Auschwitz art even more than a post-painterly art.'

In recent years his fascination with Degas and the art of that time has led him to both draw Degas (Pl 42) and re-do pictures of that period. His pastels and drawings are increasingly distorted, like late Degas, or in their sharp junctures of planes of col-

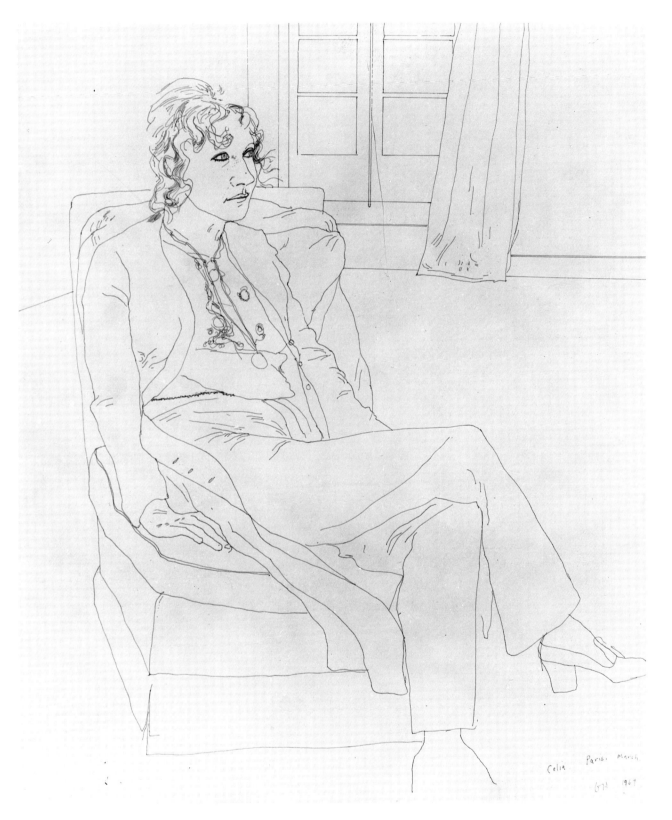

Celia Paris. March
GH 1969

44 DAVID HOCKNEY. *Celia, Paris*. 1969. Ink, 43.2 × 35.6 cm (17 × 14 in). Private collection

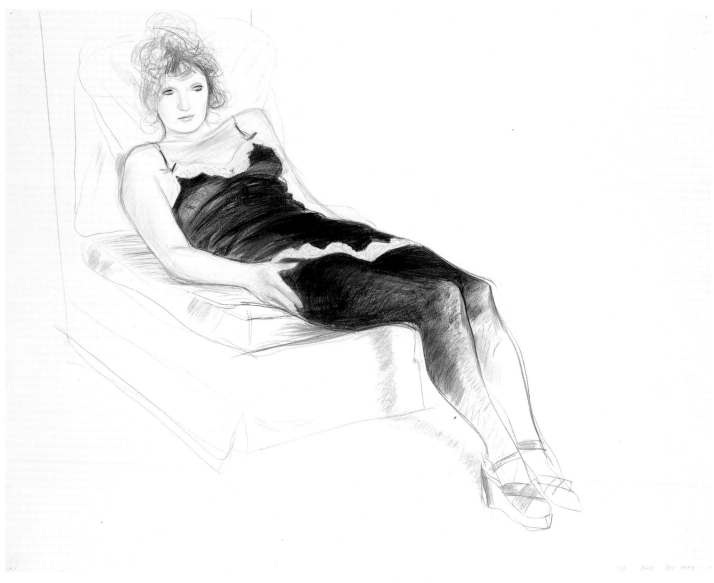

45 DAVID HOCKNEY. *Celia in Black Slip, Paris, December 1973*. Crayon, 50 × 65 cm (19³/₄ × 25¹/₂ in). Private collection

46 DAVID HOCKNEY.
Celia, May 1984. Crayon
76.2 × 57.2 cm
(30 × 22¹/₂ in). Private
collection

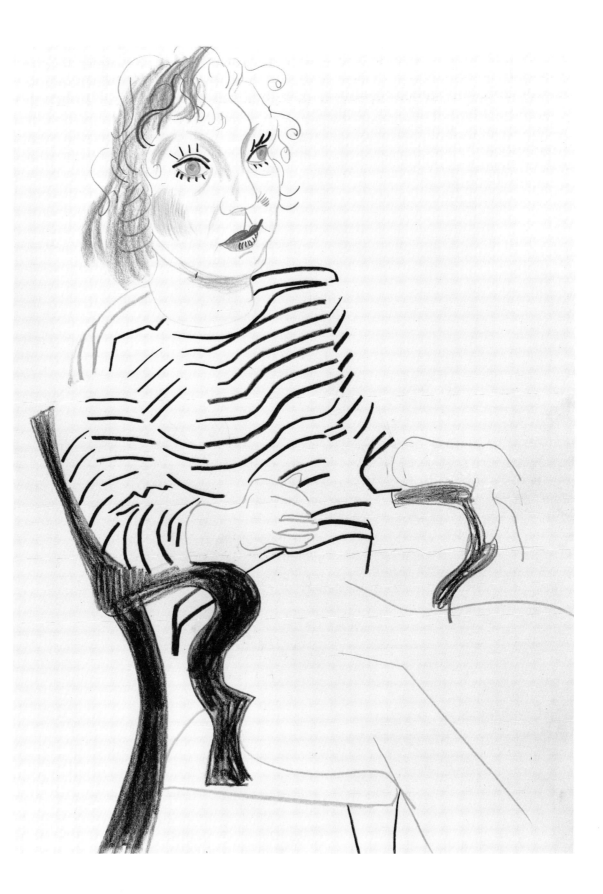

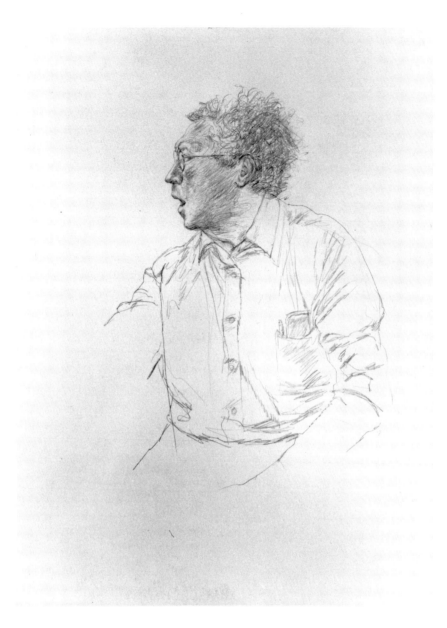

47 AVIGDOR ARIKHA.
Self Portrait shouting.
1980. Pencil on paper,
76 × 56.5 cm (29³/₄ × 23 in).
Private collection

horror of 1945, and the need to maintain a pur-
chase on this floating world? Or a revolt against
the iconoclasm of Judaism, a literary and not visual
tradition?) Arikha gave up painting his abstract
paintings in the sixties and for several years drew
exclusively from life (Pl 47). He emphasizes the
special situation of making a portrait drawing: 'not
a trace transmitted through an inert lens, but a
double-track trace: the sitter through the painter.
Two lives marked on one surface.' The drawing is a
record of marks made at a particular time, in a par-

ticular place. The frankness of his portraits is
equalled by that of Lucian Freud's. With Freud the
focus will settle intensely on head, or hands, or
genitalia; the lump that is the physical body seems
almost malleable: kneaded with the hands to dis-
cover its quiddity, its palpable energy (Pl 48).

To believe in the art of Frank Auerbach is for
many not a mere aesthetic preference, but an act
of faith. The art of drawing is an existential act per-
formed in camera, the sitter held in the gaze, the
artist working and re-working a sheet of paper.

48 LUCIAN FREUD.
*Two Figures for Large
Interior (after Watteau).*
1983. Charcoal, turpentine
and white crayon,
76.2 × 56.5 cm
(30 × 22¼ in). Private
collection

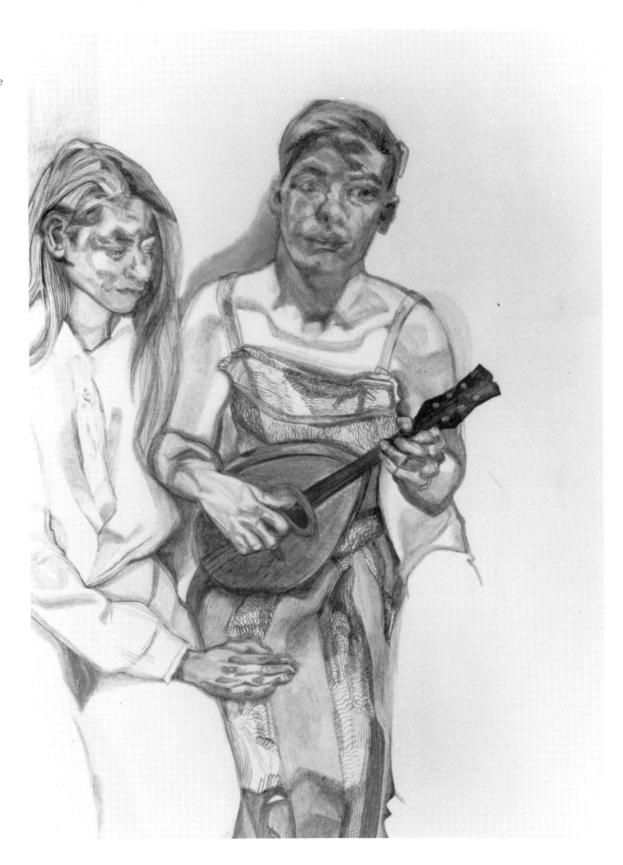

Huerbach's fellow artist Leon Kossoff writes of his practice: 'Drawing is not a mysterious activity. Drawing is making an image which expresses commitment and involvement. This only comes about after endless activity before the model or subject, rejecting time and time again ideas which are possible to preconceive. And, whether by scraping off or by rubbing down, it is always beginning again, making new images, destroying images that lie, discarding images that are dead.'

The heads that emerge from this process have an impressive architecture: towers of struts and girders, built against a half-erased site (Pl 50). Or else they appear as faces crystallizing in a reverie. A brief questioning of the variety of marks employed, their different rhythms and weightings shows how complex these drawings are (Pl 49). Whether this is a result of their endless re-workings or just a brilliant technique is debatable. Indeed given the extraordinary prestige accorded him in Britain, if not in America, one may question whether such habitual re-working is necessary; whether it is in part an obsession with creating a patina of authenticity? If one compares him to Rembrandt, as is often done, cannot one say that his range of subjects and expression is fantastically limited?

In 1975 Leonard McComb destroyed nearly all his previous work for it was at that point that he felt he had come to a greater understanding of nature, and that his earlier work was vitiated by over-concern with contour edges. He felt they were frozen. He began when looking at things to look more at their centres and see them more in terms of light. He writes that, 'in my drawings and watercolours, contour edges gave way to short pulse notations, trackings and auras. These further extended the contour, and helped me to locate the forms according to their spatial relationships. Sometimes these trackings cross one another and create diagonals of energy which cascade in dots over the form.' The forms, normally nudes posed hieratically like Egyptian statues (Pl 51), seem to dissolve into an inner life. As with the work of

Samuel Palmer or Morris Graves such drawings will seem stilted unless read sympathetically. This is probably true of all such work concerned with a quietist attainment of grace, a grace for whose attainment the slow build up of marks provides an equivalent.

Philip Pearlstein offers a very different type of figure drawing to any other artist mentioned here. His work, normally of nude figures posed in the interior, is a cool, formal art without emotional involvement, narrative or symbolism. He has written

(opposite)
50 FRANK AUERBACH. *Head of J.Y.M. 1984.* Charcoal on paper, 78.7 × 71.1 cm (31 × 28 in). Private collection

49 FRANK AUERBACH. *Head of Catherine Lampert VI.* 1980. Chalk and charcoal on paper, 77.2 × 58.4 cm (30³/₄ × 23 in). Private collection

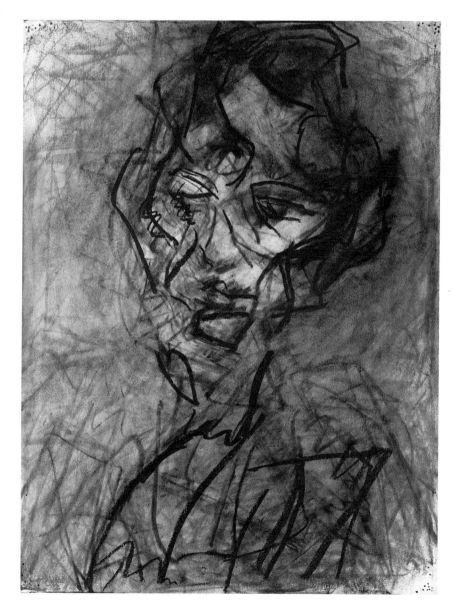

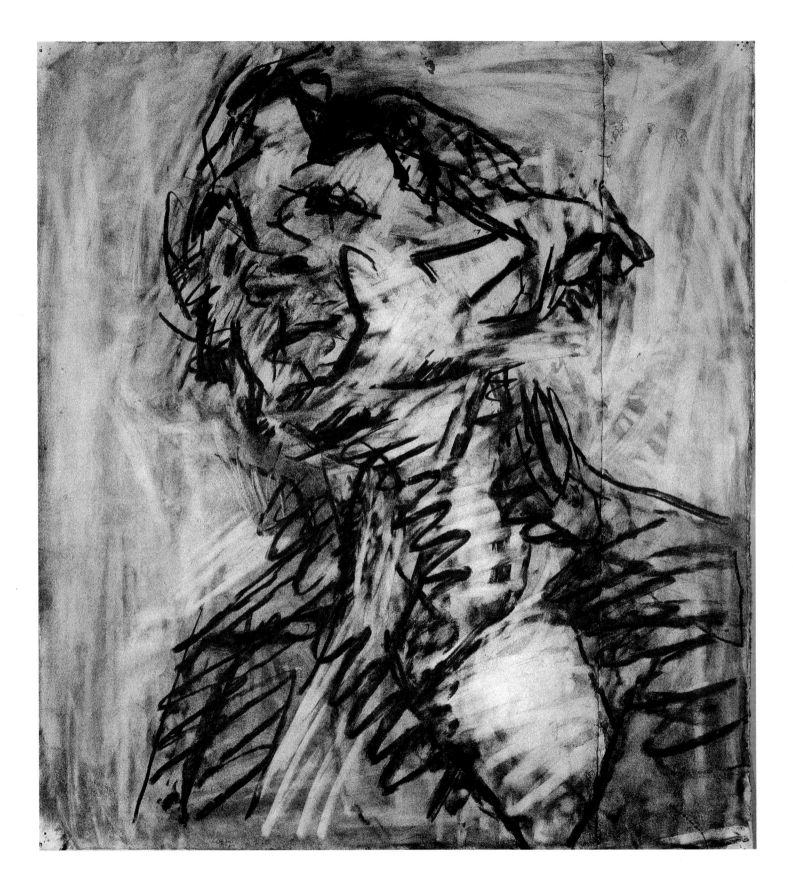

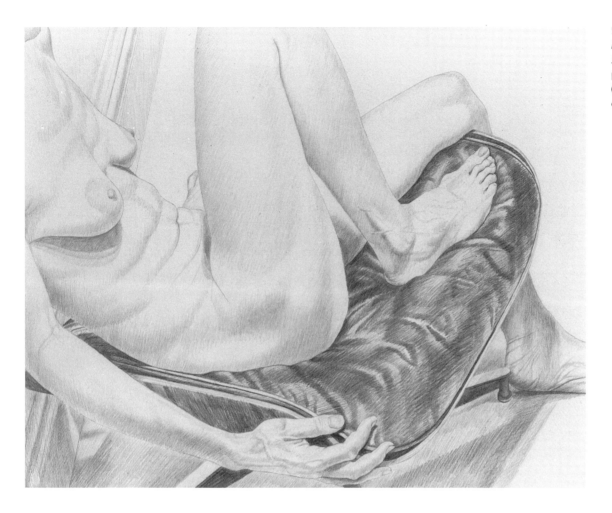

51 PHILIP PEARLSTEIN.
*Female Model on Eames
Stool*. 1976. Pencil on
paper, 58.4 × 73.7 cm
(23 × 29 in). Private
collection

of how the figure is like a landscape element or 'a kind of extravagant still-life object'. The real meaning of his art is to be found in the formal construction and execution (Pl 52), especially here in the baroque sweep of lines from top left to bottom right where it is caught by the female model's back like a swag by a rope and swung around into the reflection . . . This is the frozen music of ornament at its most intense.

In that the improvisation and conceptualisation has happened before the pencil and paper meet we could say that the drawing is in the arranging of the models. The drawings *per se*, which are increasingly large and meticulously crafted in line and shading, are finished works like the watercolours (Pl 51). It is a moot point whether watercolours such as these are paintings on paper or

drawings: in their emphasis on touch and in the irreversability of the marks they are drawings. This is felt by Pearlstein too, who comments: 'It is a challenge to get it right the first time. It is like an athletic event. What goes on the paper is what you can see and can't correct and cover up because traces of your correction remain visible. Using watercolour exposes the ideas and processes with which I build my paintings.'

When Warhol (who had coincidentally been Pearlstein's room-mate when they first came to New York) began drawing again in the mid-seventies his approach was the opposite to that of Pearlstein's: whereas Pearlstein never uses photographs, Warhol projected up transparencies and traced them. Either Warhol's sparse, elegant line, as in the drawing after Munch (Pl 52), or his

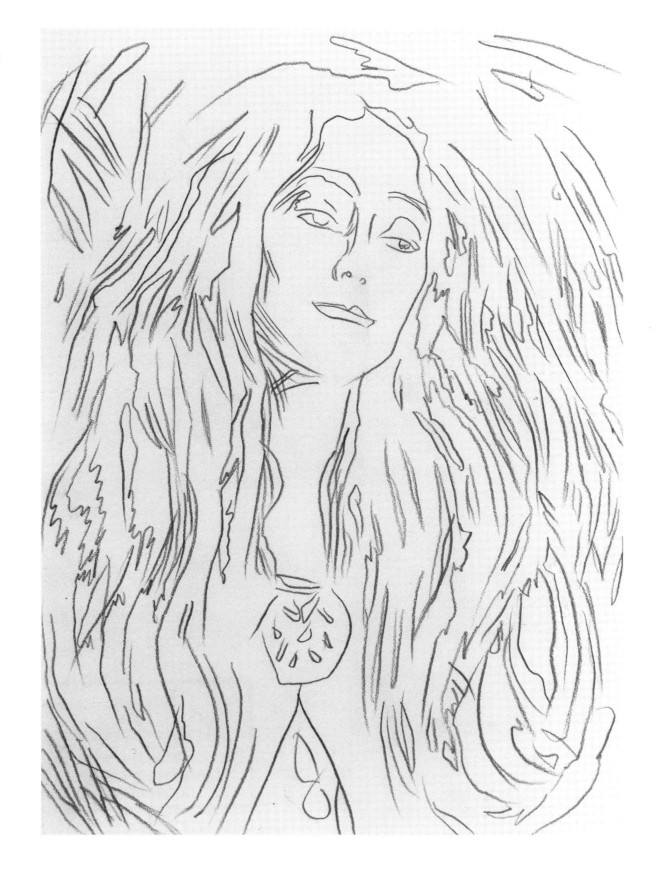

52 ANDY WARHOL.
Untitled (Munch Madonna). 1985. Pencil on paper, 80 × 59.7 cm (31³/₄ × 23¹/₂ in). Private collection

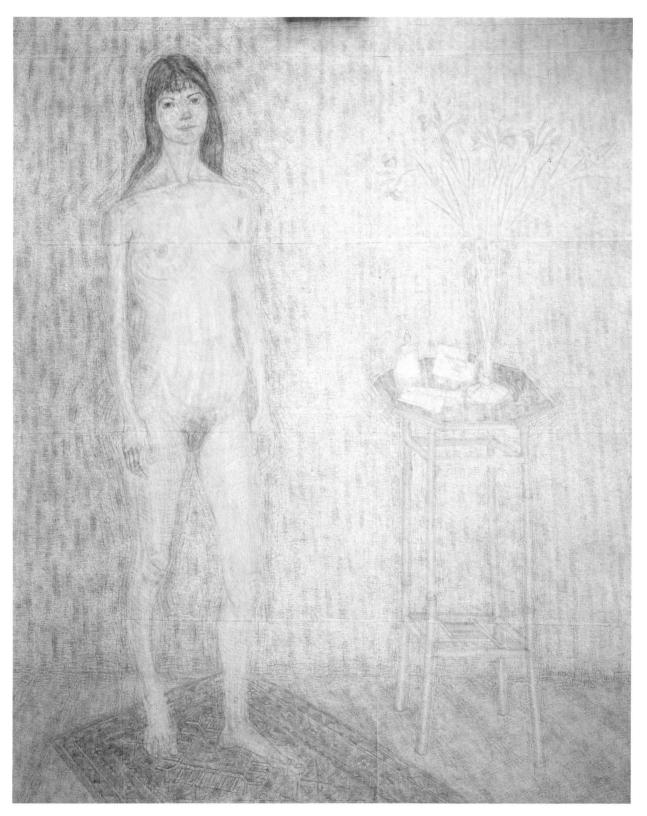

53 LEONARD McCOMB. *Portrait of Sylvia Pasella*. 1981. Watercolour, 243.5 × 195.5 cm (95⁵/₆ × 77 in). Collection the artist

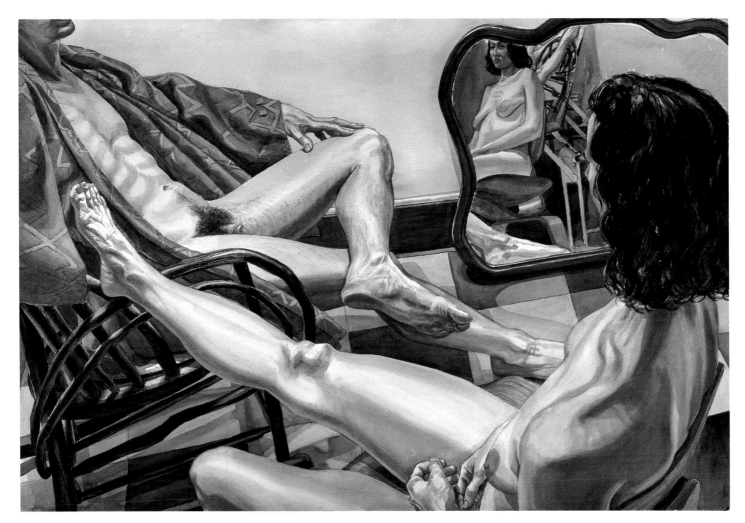

54 PHILIP PEARLSTEIN. *Male Model with Kimono, Female Model with Mirror*. 1985. Watercolour on paper, 101.6 × 151.8 cm (40 × 59³⁄₄ in). Private collection

55 ANDY WARHOL.
Untitled (Reagan Budget).
1985. Acrylic on paper,
80 × 59.7 cm
(31³/₄ × 23¹/₂ in). Private
collection

quizzical humour, as in the drawing of Reagan (Pl 55), saved this from tedium. It is a common belief of post-modernist thought that over the course of this century representation has replaced nature, or the 'natural'. The French philosopher Jean-Francois Lyotard claims, 'data banks are the encyclopedia of tomorrow. They are "nature" for post-modern man.' The status of nature as sole repository of truth has gone: truth is rather to be found in the conflict of different types of representation. Against this, the return to the life room asks whether one can still make a stand for the figure

being sovereign, as the touchstone of real experience. Paradoxically by taking the opposite position Warhol's work poses the same question: do we believe in the traditionalist's nude model posed in the life room or in the glossy poster of Madonna on the wall outside?

One who firmly believed in the reality of the life around her, if not necessarily that of the life room, was Alice Neel. Above all else she was a portraitist (Pl 56), one concerned with discovering that psychological terrain beneath the skin. Her drawings are jumpy, spiky and sharp — almost as if trying

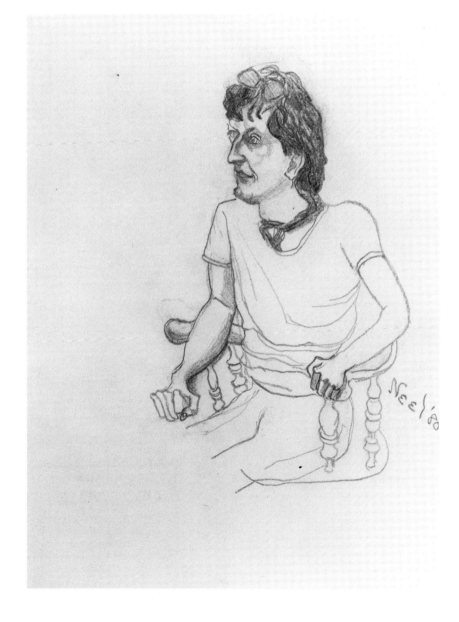

56 ALICE NEEL.
Micel Auder. 1980. Pencil on paper, 40 × 29.9 cm (15^3/$_4$ × 11^3/$_4$ in). Private collection

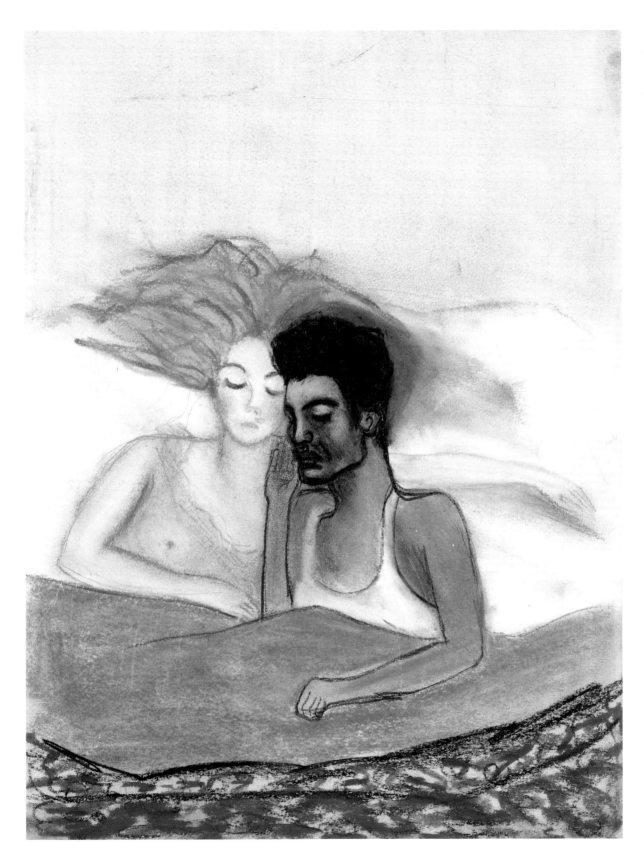

57 ALICE NEEL.
Alice and Jose. 1938.
Pastel on paper,
29.9 × 22.9 cm
(11³/₄ × 9 in). Private
collection

58 PIERRE KLOSSOWSKI.
*The Meditation of Roberte
on the Deathbed of Octave
(I)*. 1980. 170 × 100 cm
(67 × 43¹/₂ in). Private
collection

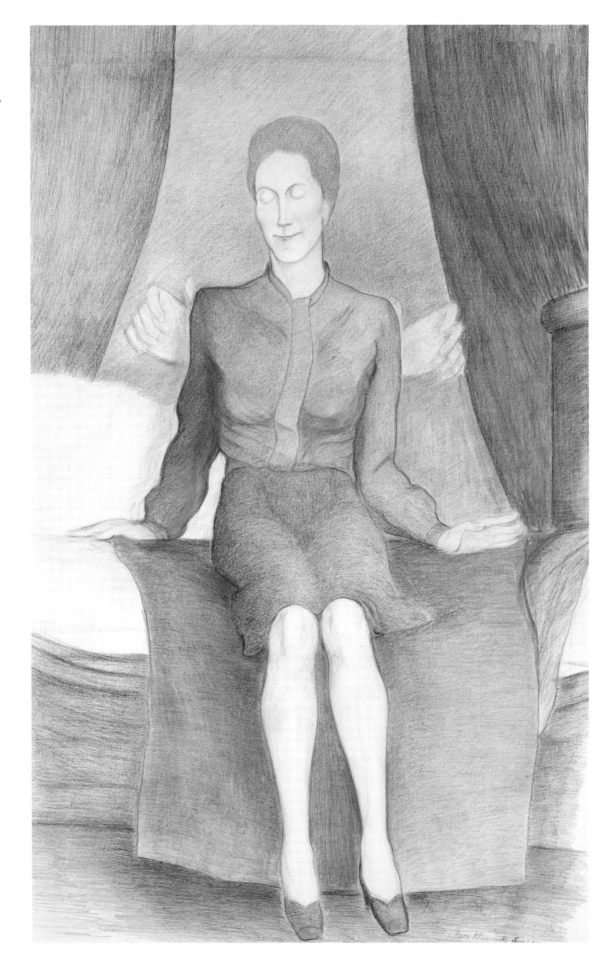

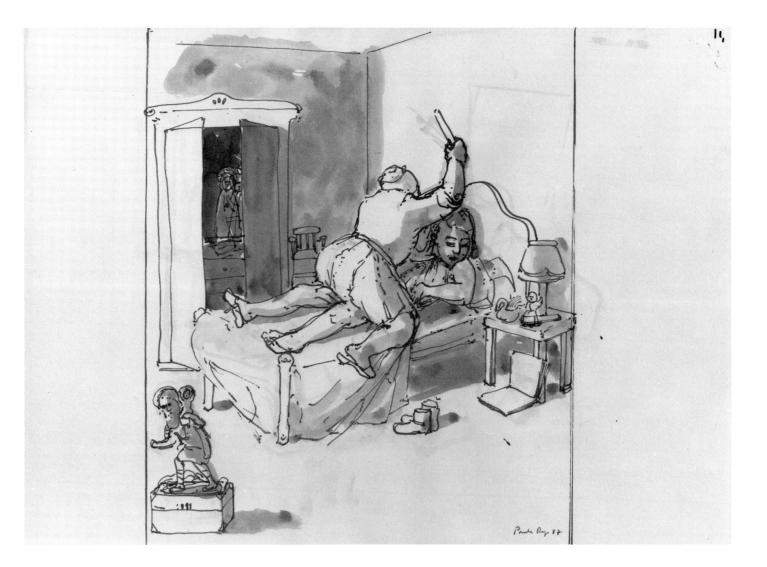

to hold appearances down with tacks. The gaw-kiness of the poses is to let the natural person speak. Her drawing, like her life with its political commitments and social openness, had to do with a belief in the transcendental virtue of honesty. In a late interview, she remarked of a self-portrait (nude) done when she was eighty years old, 'Frightful isn't it? I love it. At least it shows a certain revolt against everything decent.'

With Neel it is not a matter of her work being stylistically influential, but a matter of the import-ance of her example as a woman making serious art out of the life and things around her. As if 'reporting from the front line', drawing here is like

a diary entry in its candor and immediacy. Many drawings, like that of herself in bed with her lover (Pl 57), were probably unexhibitable at the time they were made. This drawing may be candid, but it is never unsophisticated, one notices the adroit use of contrasting marks, fast on her hair, com-pacted on his.

A diary may also be in the form of allegory or metaphor. This seems the case with Paula Rego's drawings with their echoes of Goya's *Proverbs* drawings (Pl 59). These are scenes either of dom-estic violence or of animals encountering people. Her fluctuating ink and wash makes the drawing hover uncomfortably between the admonitory (a

59 PAULA REGO.
The Mother in Law. 1987.
Ink and wash
29.5 × 25.4 cm
(11½ × 10 in). Private
collection

Victorian woodcut) and the confessional (the autographic).

In his novel *Roberte Ce Soir* Pierre Klossowski, brother of the painter Balthus, writes of Roberte's abduction by a maniac who has her tied, half-stripped, to parallel bars. His overwhelming desire transpires to be to lick the palm of her hand. Klossowski has subsequently made various life-size drawings of scenes from the novel, and others, not in the novel, where Roberte continues to be an object of sexual desire and fantasy (Pl 58). When he first exhibited in 1967 the surrealist artist André Masson wrote of these drawings: '. . . the relation between the graphic work and the written work is not that of illustration: prolongation would be the more exact term. The effect of these life-size *tableaux vivants* indescribably evoking a Sadian ceremonial is that of rapture.'

The prevalence of photographic pornography since the sixties and the grave concern of its effects highlight the way we think about the drawing of the nude and the portrayal of sexuality. Can art be different? Is there some truth in the old claim that photography gives us pornography, drawing gives us eroticism? Kitaj's images of sex give us all that pornography denies: psychologically complicated situations, formal invention, wit, whilst the viewer is held in a self-conscious position. Some in the gay community would make a similar defence of the erotic drawings of Tom of Finland. Elsewhere Pearlstein writes of having saved, 'the human figure from its tormented, agonized condition given it by the expressionistic artists, and the cubist dissectors and distorters of the figure, and at the other extreme I have rescued it from the pornographers, and their easy exploitation of the figure for its sexual implications.'

Lyotard argues that pornography with its 'realism' is 'becoming a general model for the visual or narrative arts which have not met the challenge of the mass media'. Art must 'foreground' the way reality is constructed in order to rescue us from these complacent fantasies. Likewise Alan Soble in his book *On Pornography* sug-

gests that pornography is the end result of our culture's emphasis on visuality at the expense of other senses, especially touch. Such a de-sensitization of the body has led to both alienation and, effectively, a dismemberment of the body. Pornography both reveals and inculcates this dismemberment in those who consume it. Arguably because drawing as an activity and result is never totally about creating illusions of reality, and because it is always to do with sight *and* touch it runs against the grain of mass media representation.

In his writing Klossowski makes great play with the notion of the *simulacra* (what many see the mass media as providing): that the figures in his drawings are not representations, but replacements. Of them Klossowski writes, 'the spectator actualizes himself by contemplating the figure which is offered to him as his victim The viewer must find himself face to face with that part of himself which he could recognize only if he found it outside himself: this embracing arm is his own, it is he who is stroking that part of the body.' Masson's description of the drawings as *tableaux vivants* is pertinent: this is a staging in which we paradoxically become involved. We are caught in a trap when we attempt to elucidate our responses: the drawings are at once elegant and laborious, there is little 'handwriting' to help us here. It does not simplify matters to learn that Roberte always has the features of Klossowski's wife Denise.

Klossowski's work may be a curiosity but it is, I believe, an illuminating one. Werner Tübke of East Germany aspires to a more traditional and rounded role as artist and draughtsman. Too little known in the West he is for some the nearest to a complete figurative artist today. In part this relates to his position where he can be seen as working for a culture at large, not just an 'art world clique'. (What other artist here would be asked to do a 123 metre long mural on the history of the reformation and the peasant wars?) A prolific drawer he will use different styles to carry different references. He speaks as if at home in a tradition others feel alienated from: 'My decisive starting point is and was

Stockholm März 83

61 WERNER TÜBKE.*Hill Scene*. 1981. Red Chalk on grey prepared paper, 43.7 × 60.4 cm (17¹/₄ × 23³/₄ in). Private collection

(*opposite*) 60 WERNER TÜBKE. *Girl from Stockholm II*. 1983. Pencil on paper, 24.3 × 19 cm (9¹/₂ × 7¹/₂ in). Private collection

the study of nature. Not side by side or in addition, but in immediate connection to this I strive to use periods of realism in the history of art and to make them come alive ... I feel embedded in the axis of time in the most natural manner.' However, certain aspects of his work mark him down as very much our contemporary: a mannerist delight in autonomous lines playing over figurative subject matter (Pl 60), similar to that we find in Johns or Baselitz. It is this delight in the various modes of drawing that holds his work back from dull pastiche. His drawings appear to constantly break down and start again: figures sit on the page quizzically, lines jump about or fizzle out (Pl 61). His work differs from the nineteenth-century academic, to whom he may be unthinkingly compared, in both the wit and sexuality of his mark-making. Whether it be in sketches for murals, portraits or metaphysical scenes of figures on the beach (Pl 62) (Picasso is the obvious influence here), we are aware of a critical consciousness, at times ironically detached, at times represented candidly and straightforwardly. Moving from the archly symbolic to the graphic realism of a precise depiction of open heart surgery, such heterogeneity marks him as our contemporary, as much as those other heterogenous artists Bruce Nauman or Sigmar Polke.

62 WERNER TÜBKE.
Venus on the Beach. 1968.
Pencil on paper,
50.9 × 73 cm (20 × 28³/₄ in).
Private collection

5 NEW FIGURATION & DRAWING: AGAINST THE GRAIN

'When one sits down to do a drawing, one's inclination is to do it in a very harmonious way. I hate that. I can only get my artistic result by breaking away from the harmonious drawing, by being very attentive, highly disciplined, and aware that I am working against all that, that I am going against the grain.'

GEORG BASELITZ (1983)

Against the grain of a modernism grown slack and decorative, against the grain of classic figuration, against the grain of the conceptualist's denigration of painting and drawing, against the grain of good taste, perhaps even against the grain of nature itself: so seemed that wave of painting, at once figurative and gestural, that swept across galleries and studios at the start of the eighties, especially in Germany and Italy, and which was so inadequately called neo-expressionism or new figuration. It has become an orthodoxy now. With its emphasis on improvisation, imagery and the autographic it inevitably gave drawing new importance, as is witnessed by the frequency with which many of the artists in this chapter have had exhibitions of drawings alone. In an age of alienation and dismemberment an art based in part on subjectivity and the validity of the artist's personal touch seemed too problematic. New figuration was a matter of going ahead with the project anyway: at its heart was to remain a knowing suspicion that it was attempting the contradictory.

It must be emphasized that new figuration was not something that began in the eighties, but something that came to the fore at that time. An artist such as Baselitz had been working for twenty years by then; indeed one could say that the drawings he produced in the sixties were a highlight of that period.

Automatism, grotesques, blasphemy, violence, curving or convulsive lines that seem to endlessly mutate into entrails, droppings or bloated corpses; tiny heads caught in lubberly bodies; once heroic figures posed on a heathland, around them and through them an aura of writing lines. Good health is tangled up with putrescence. These early drawings by Baselitz are at once both repellant and morbidly fascinating (Pl 65). Faces, trees, landscapes, the sky – all are about to be absorbed by fluctuating marks which, though abstract, seem to have an animal or insectoidal life of their own. Twenty years later in a lecture Baselitz, with customary energy and opacity, intoned: 'LINE, it can shoot into the eye from the background, or even right through the canvas; ORNAMENT, braided, twisted, wound, even falling, can also be as SNAKE or ROPE; DOT as DOT as SPOT as PILE, like FLAT-CAKE, also flies sometimes across the plane of the canvas; the PLANE itself, impossible to imagine everything e.g. as HAIR, as BODY as CHEST of a hero, as green EYE or even as CHRISTMAS TREE, as OCEAN, if possible, not in perspective; . . .' In this rhapsody of unending transformation the key word is ORNAMENT. In the sixties Baselitz was collecting mannerist prints, which thus deploy ornament to outdo nature: line is set free from its function of imitation. The 'mannerist addiction to excess' of which Baselitz speaks is taken further.

Other artists than the sixteenth-century mannerists (then little regarded) were important. Baselitz had an early interest in the art of outsiders, Vrubel or Gallen-Kallela, or of those who had been insane, Artaud or the Swede Josephson. He has talked of how when he went to Paris in 1959 he looked at, 'Fautrier then for the first time, and most important, I saw the late Picabia for the first

28.XII. 85 — Baselek

65 GEORG BASELITZ.
Untitled. 1963. Pencil, ink
and black chalk,
48.5 × 31.5 cm
(19 × 12¹/₂ in). Private
collection

resentation, the eternal reinvention of human forms.' Or again, '1880–1920 was the last time the depictive blood was so strong (and innovating), so why not go to school where the real stuff left off? It's funny that the new young guys are getting off on Picabia, Nolde and Kirchner etc. I guess it suits them.'

Baselitz is of course no new young 'guy': he was born only six years after Kitaj. What we have here are two very different views of which strands in twentieth-century art history are central; of which branches can still bear fruit. Whereas for Kitaj art history is continuous, if in decline, for Baselitz and others it is discontinuous: their models were not in the canon of good taste, but the rebels.

Especially indicative of this alternative tradition is Antonin Artaud, the thirties dramatist and apostle of the theatre of cruelty, who after leaving the lunatic asylum in 1946 produced a clutch of drawings, at once angered and visionary. As in Baselitz, different images split into each other, faces contort and are dissipated, gashing lines proliferate; yet despite this threat of implosion, of chaos ingesting the images, the drawings remain curiously satisfying. A terrible beauty lingers.

Since 1969 when he began painting and drawing his motifs upside down, as a strategy to empty literal content out of his work, Baselitz's drawings have become more open. The lines do not struggle so with the image. A greater range of marks, moods and sensations is brought into play. It is as if he has moved from an expressionist mannerism to a classical mannerism. Though his drawing may have become less intense and more uneven than in the sixties if often attains a severe monumentality, a *gravitas*. The complex sets of drawings in his *Fight-Motifs* (Pl 66) of 1986 have a formality that is almost ceremonial or hierarchic. Colour, too, has taken a far greater part in his recent drawings, giving an intensity and character to the figures and motifs (Pls 63 & 64).

If Baselitz's early drawings appealed to a sense of the repressed, his compatriot A.R. Penck's drawings sought to identify archetypal motifs. Just

time. And I saw Michaux.' All these artists' work is distinguished by a drawing line that has grown wild or delinguent. It is worth comparing this group of artists with the pantheon Kitaj lays down for the early twentieth century: 'Cezanne, Degas, Munch, Matisse and Picasso were conducting some of the last fire and brimstone into the rep-

66 GEORG BASELITZ. *Kampfmotive III* (Fight-Motifs III). 1981. Charcoal on paper, each drawing 100 × 70 cm (39^1/$_2$ × 27^1/$_2$ in). Collection Kumpferstichkabinett, Basel

67 A.R. PENCK. *Untitled*. 1974/6. Biro and gouache, 42.2 × 59.5 cm (16^1/$_2$ × 23^1/$_2$ in). Private collection

(*opposite*) 68 ANSELM KIEFER. *From Oscar Wilde for Julia*. 1974. Watercolour, 40 × 30 cm (15^3/$_4$ × 11^3/$_4$ in). Private collection

von Oskar Wilde
für Felix

as in Borofsky's work the stickmen of primitive rock drawings or a children's sketchbook re-emerge. Penck is not, however, a primitive, but a sophisticated artist. Prior to 1980 he called himself a picture researcher: his drawings are attempts to find or invent possible systems for the world, language-like codes to describe or allegorize a divided culture. One should not let the instant appeal of his apparent innocence blind one to the way his natural facility for fluid lines is always brought nose to nose with this conceptualizing intention (Pl 67). After 1980 and his departure from East Germany his drawings have become more purely concerned with the possibilities of free drawing *per se* (Pl 69).

Although normally characterized as a painter Anselm Kiefer sees himself as pre-eminently a maker of books. It is in them that we most clearly see how drawing operates in his idiosyncratic *œuvre*. At its most extreme his drawings are over-worked totally with a black wash made from iron oxide and linseed oil; more often the books, filled with blown-up photographs, will be overdrawn in emulsion, aquatec or graphite (Pl 70). Drawing here is a way of reintroducing meaning into a post-war world that has become numb. On one large separate photographic work of himself standing in a smock is drawn, with childlike simplicity, a painter's palette where the heart would be; rays, as from a star, emanate from it and underneath are written the words from Kant: 'the starry heavens above me and the moral law within me'. He poses again in another work from 1980 as Gilgamesh, the Sumerian hero in search of immortality, whilst all around are drawn shattered cedar trees. Drawing is used to make a staging of the mythic. Much as in Beuys, the works with their grossly material marks and their gnomic meanings, are intractable. Far more immediately appealing are the water-

(*opposite*)
70 ANSELM KIEFER. *St John's Night*. 1980. Photographs of 1978 on P90 projection paper overpainted with emulsion, graphite and aquatec, lower mounted with cardboard, 48pp including cover, 59 × 43.5 × 12.7 cm (23^1/$_4$ × 17^1/$_8$ × 5 in). Courtesy Antony d'Offay Gallery

69 A.R. PENCK. *World of Stones 8*. 1985. Ink on cardboard, 44 × 75 cm (17^1/$_4$ × 29^1/$_2$ in). Private collection

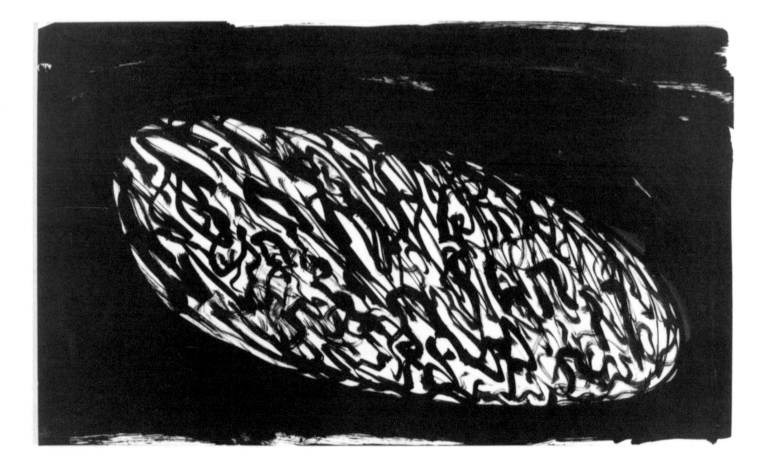

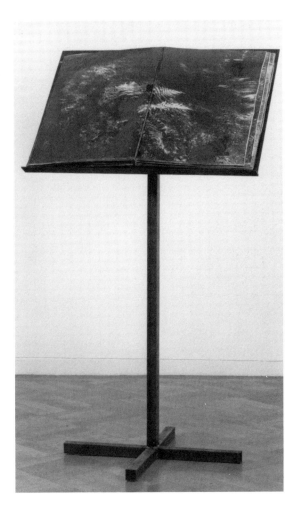

with scribbles, messages and numbers) show how vulgarity is subverted into art. This is the apotheosis of the doodle. The automatic drawing of the seance (only here there are no ghosts, only a noisy population chattering on the phone), and the American all-over painting with its mythic pretensions are evoked in these mazes of the banal, the witty and the strange. If Artaud's drawings gave voice (or voices) to schizophrenia, these drawings of Polke's give voice (or voices) to a whole culture's schizophrenia.

71 SIGMAR POLKE.
Why Can't I Stop Smoking?
1963. Biro on paper,
29.7 × 21 cm
(11½ × 8¼ in). Private
collection

colours where, though the disputatious or conceptual element is never far away, a brilliant, and often lyric, sense of colour is allied with his crumbling line (Pl 68).

If Beuys adopted the role of shaman, Sigmar Polke adopts more that of a clairvoyant. Sardonically the 'higher powers' that speak through him tell him to paint and draw the *kitsch* of European petty bourgeois life. Not only because of their tacky subject matter, but also because of the plaintive dumbness of the drawings, his work from the sixties has a strange melancholy (Pl 71). Over the years as his work has diverted and re-emerged in different modes the canniness with which he has unmasked this world's visions has become apparent. The large *Telephone Drawings* (Pl 72) of 1975 (sheets of paper kept by the phone and covered

72 SIGMAR POLKE.
Telephone-Drawing. 1975.
Felt-tip and biro on paper,
70 × 100 cm
(27$\frac{1}{2}$ × 39$\frac{1}{2}$ in). Collection
Kunstmuseum Berne, gift
of Toni Gerber

73 WALTER DAHN AND
GEORG JIRI DOKOUPIL.
*Robert Ryman Can You
Hear Me?* 1980. Charcoal,
varnish and dispersion on
canvas, 112 × 195 cm
(44 × 76³/₄ in). Private
collection

If automatism is the crucial surrealist drawing technique adopted by today's artists, that other surrealist device, the *cadavre exquis* (where a group of artists each add to a drawing, each being unaware of what the others have drawn), is reawoken by Dahn and Dokoupil's *Robert Ryman, Can You Hear Me?* (Pl 73). The drawing shackles together different styles, different voices, and so opposes the immaculate white-on-white abstraction of Ryman. Dismemberment (the clock-headed man wears a head for a watch) is gleefully accepted as a condition of contemporary life. Babel becomes not a symbol of horror, but the true image of the modern city. One may note that their work is funny in both senses: comic and strange.

Italian artists such as Cucchi, Clemente and Arcangelo, ignore both such neo-dadaist prank-sterism and northern heart-searching as to the status of the artist as truth-teller. They eschew epistemological complexity and draw as if making statements is no problem. There is no uncertainty in the way Clemente so readily uses his own face in his own drawings: the pose he adopts for the illustration to the text by Allen Ginsburg is that of revelation, but the revelation of a conjurer as the dove flies out of his hand or mouth (Pl 74). There seems to be little self-consciousness in the way Arcangelo or Cucchi evoke the seamlessly-joined mythic and physical aspects of the areas they grew up in. In the village near Benevento where Arcangelo grew up the peasants touched an obelisk in the main square before going to work. *Magia*, everyday magic, is about touching. Fires, lit to patron saints, mark the night's darkness.

74 FRANCESCO CLEMENTE. from *Images from Mind and Space, New York City*. Watercolour with holograph text by Allen Ginsburg, 14.5 × 20 cm (5¼ × 8 in). Private collection

The shadows of people after they die linger as smudgy traces. His drawings are part of the unity of such a life: he uses charcoal or ashes to draw with, 'earth that is worn out, the shadow of earth'. Whether on paper or on canvas (which is stretched out across the floor so that the texture of the boards is picked out) his art is one of invocation and propitiation. Touching is the crucial act: his hands grind unbroken fragments of charcoal into the paper, as with a lover's caress, quick thumb strokes smoothing it out, fingers dragging the darkness into shapes that become animate presences (Pl 75). Like Beuys he appeals to nature, but to a particular notion of it, one far removed from the beneficient nature of romanticism.

Like Arcangelo, Enzo Cucchi, an artist from Ancona, appeals to peasant knowledge, or else gives voice to a longing for atavistic myth. However, one should point out that like Arcangelo he is not himself a peasant. It is part of a pose: new figuration at times bears witness to the belief that one can get at truth by adopting poses, by acting. Invocation is the *raison d'être* of Cucchi's drawings. His frequent pronouncements on drawings, with their high oracularity, ring strange to the English or American ear:

'Drawings can unfailingly be found during the day in this Mediterranean cradle among people of the sea, and at night-time in Africa, where the painter wants to immortalize his battle against the

(*opposite*)
76 FRANCESCO CLEMENTE. *The Weight of Water*. 1981. Pastel on paper, 61 × 45.8 cm (24 × 18 in). Private collection

75 ARCANGELO. *Untitled*. 1986. Charcoal, 50 × 35 cm (19³/₄ × 13³/₄ in). Private collection

European foreigners in images.'

'All drawings are lost in battle: people can only see the ravages.'

Drawings are spoken of as if they have an animate presence like people or spirits:

'Great longing compels the drawings to continually desert the regions, the storehouses of the world, and to look for mythical and legendary connections even past the Parthenon. These drawings, however, stay sad and gloomy, aware that approaching the nearness of the gods is a new struggle, as already in the past they came down against the enemy in order to protect the great feeling of painting.

They want to protect the customs, want to busy themselves with the construction of a picture, the building of sense. They want to keep watch over the quietness of things. Drawings have a name, a title, a feeling, just as women have a name and animals have a name, and plants too . . .'

It is hard to respond to all this rationally. Cucchi is seeming to imply that this is the real, vital world expressing itself. It is presented as a kind of religious experience, divorced from and older than the church: here drawings are not just a way of demonstrating the truth, or even a way of getting at the truth, they are truth. They embody mystic and primal knowledge and energy. However, there is nothing ethereal about these drawings (Pl 76) with their often solid imagery: extended houses, skulls, trees, caves. Lumps of darkness, perhaps clouds, or pools, or figures, even loaves of bread, wander across the white pages (Pl 79). The placement of the elements across the page is crucial: like tightening a drum it energizes the whole page – and by analogy the world they create.

The young Italian Francesco Clemente may make statements as orotund as his compatriots, but he is a jackdaw rather than a seer with an obsessive vision. It is difficult to think of any artist with more facility and inventiveness. His work shows some of the pitfalls that face the new figuration artist: pestered by a constant demand for work from a buoyant art market, combined with a belief

that every avenue should be pursued, but with no clear criteria by which to edit out weak work, he over-produces. This is especially true of his drawings: much is brilliant, but much is repetitious and slight. Clemente's work has often been autobiographical. One result of the combination of a greedy market and a philosophy that everything should be shown is that the great bulk of drawings that, in a previous era, would have appeared only after an artist's death now, not only appears during his lifetime, but is widely exhibited – the currency of his own face and his experiences is devalued. Like Kitaj, Clemente often works in pastel (Pl 76), a difficult medium because the material is so incipiently pretty. When Kitaj, occasionally lapses into *schlock* it is because he plays for high stakes, when Clemente does so, and this is not to say he has not made fascinating pastels, one wonders whether it was not because the intention was

too trivial. Clemente's great influence is in having re-introduced to high art styles more often associated with the vernacular of magazine illustration. Not surprisingly given his graphic invention he is often at his best when illustrating or working with an existing text.

Robert Morris made his reputation initially as a minimalist sculptor and conceptualist. Around 1980 he began producing vast drawings of firestorms, related to Dresden, Hiroshima and future holocausts (Pl 80). In their scale and lack of set composition they envelop the viewer. The Heraclitean flux (a concept with which contemporary drawing seems so often entangled, its marks

80 ROBERT MORRIS.
Untitled. (Firestorm Series).
1982. Ink, charcoal,
graphite and various black
pigments on rag paper
with velcro, six panels, each
127 × 96.5 cm (50 × 38 in).
Private collection

analogous to the oscillating atoms, *anima materia*) re-appears in apocalyptic guise. The smudges and swirls are like those he would make if he tried to open this wall of paper and charcoal like a curtain: the skeletons, which are actual size, mock the viewer like a macabre reflection of his or her own body.

This is the end of the romantic search for the sublime: the nuclear apocalypse. This is the bathos of the romantic search for union with nature: to be absorbed into the firestorm. But at the same time the work is undercut by the knowledge that what is being 'represented' is unrepresentable: what we see are beautifully modulated drawings. Thus in this conflagration the stencilled bones appear like a decorative motif.

Other drawings have kept a rigorous conceptual framework. Amongst them are his *Blind Time* (Pl 81) drawings where, blindfolded, he worked within strictly defined parameters, combining scientific experiment with a seemingly desperate emotionalism. His drawings become about the fear of emptiness: about death as an experience of emptiness.

Per Kirkeby and Christopher Le Brun are two

81 ROBERT MORRIS. *Blind Time III*. 1985. Graphite on paper, 96.5 × 127 cm (38 × 50 in). Private collection

WORKING BLINDFOLDED FOR AN ESTIMATED 14 MINUTES, THE HANDS BEGIN WITH TOUCHES AT THE UPPER EDGE. PRESSURE IS INCREASED IN THE DESCENT AND MAXIMIZED AROUND THE EDGES OF THE TAPED OFF LOWER BAR.

THE RELENTLESS DEMAND FOR THE SPECIFIED MECHANISM INDICATES THE DEEPEST OF ANXIETIES WITH REGARD TO CONTROL. AND THE CALL FOR THE RATIONALIZED IS RAISED TO ITS MOST HYSTERICAL PITCH AT THE EDGE OF THE CONTRADICTORY, THE COMPLIMENTARY AND THE INDETERMINATE. TIME ESTIMATION ERROR:-1'29"

artists who, if difficult to categorize as 'neo-expressionists', have benefited by the more open situation it has created. Kirkeby talks of his poems and paintings as constructed by a complex sedimentation of images, of experiences, of thoughts, paralleling the way geological structures are made. But underpinning these constructions is the continuum of thoughts and observations: for him drawings hold the germs of future systems, poetic instants. As he says, 'diaries and sketchbooks are seed corn and thunderbolts. This is where it all happens. The big works are lies and constructed illusions In them one understands the great observations for what they were — Experiences.' Drawing brings images to the surface, makes initial combinations; a woman's head, a tree and a

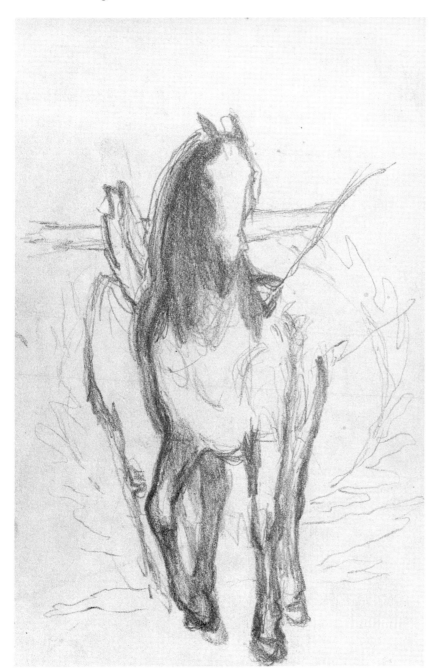

82 CHRISTOPHER LE BRUN. *Drawing from Sketchbook*. 1984. Pencil on paper, 17.3 × 11.4 cm (6⁷/₈ × 4¹/₂ in). Collection the artist

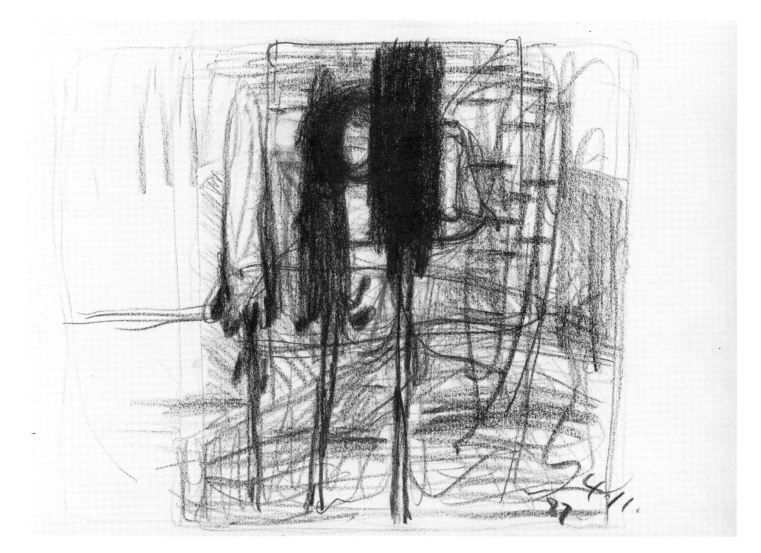

83　CHRISTOPHER LE
BRUN. *Untitled*. 1987.
Charcoal on paper.
29.6 × 42 cm,
(11⁷/₈ × 16¹/₂ in). Collection
the artist

group of markings unite as a motif. Drawing plays over memories here. A typical instance is how in one set of drawings a recurring group of marks were only subsequently deciphered as the Biblical admonition: *Mene, Mene, Tekel, Upharsin*. Like snow crystals falling in a beam of light a troupe of recurring motifs play out an unending drama: in the drawing from 1986 illustrated here (Pl 84) the motif on the left is like a tree with flowers below, or, if seen upside down, an archway with possibly Hebraic writing above it; it could also be seen as a face; it plays against the architectonics of the convoluted gestures to its right.

Drawing was initially important to Le Brun in that it was a way to go back over images from past art and find out what could be brought from them, not as an antiquarian quote, but as a living form. His sketchbook drawing of a horse (Pl 82) seems close to much art of the 1890s, Hans von Marees or Odilon Redon, but it is loosed from any literary context, left to wander with more uncertain and puzzling connotations. It is also true to say that these sketchbook meditations on past art were part of an attempt to discover what beauty is, or could be, today.

Increasingly his drawing is subsumed into his painting: the initial ideas that are lost behind the paint. A drawing such as that shown here from 1987 (Pl 83) is used to get into a state of mind with which to make a painting, it is a rehearsal of marks

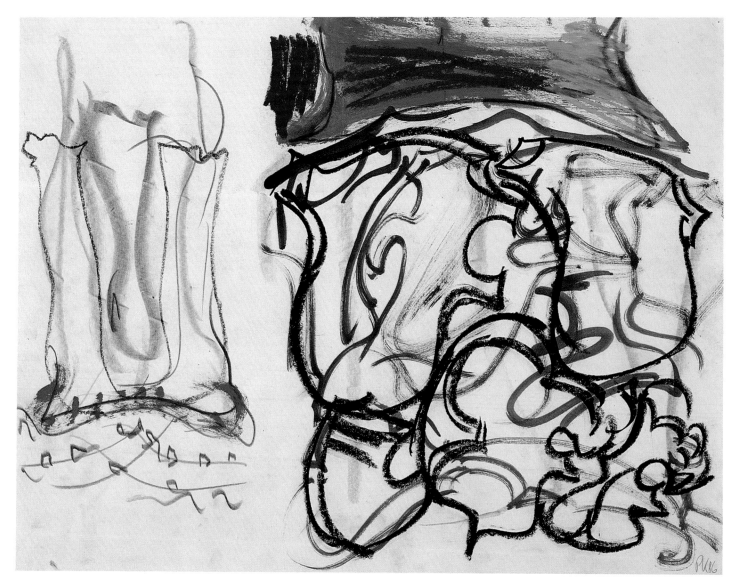

84 PER KIRKEBY. *Untitled*. 1986. Oil, pastel, crayon, charcoal and pencil, 50 × 65 cm (19^{1}/$_{2}$ × 25^{1}/$_{2}$ in). Private collection

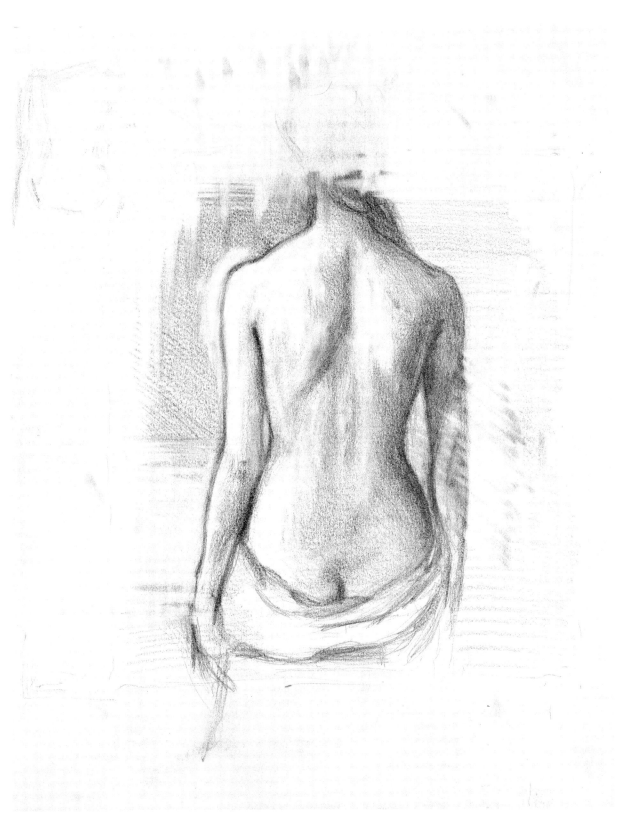

85 CHRISTOPHER LE BRUN. *Untitled*. 1983. Pencil on paper, 38 × 30.6 cm (15 × 12 in). Collection the artist

as much as it is a meditation on a composition. Indeed the motif here of the three trees has almost become the ground against which the drawing, with its loops, shimmers and root-like lines creeping to the left, works itself out.

The life drawings he made in the mid-eighties may seem like a return to the figure, but even here, although he is concerned with the discipline of drawing from the nude, Le Brun plays off the traditional image with an abstract mark-making process (Pl 85). The marks around the torso do not just fill in the background, they are active, bustling around, autonomous. They create a logic with the figure as motif: this determines that the left arm shall be strongly outlined, but the right arm shall be eroded. This is not an attack on the body beautiful, but an attempt on the concept of beauty, of formal coherence: poignancy has been moved another step on from the expectations of the life room.

6 THE NINETIES: *READING IN THE DUST*

'A flower is a metaphor for a drawing.'
DONALD SULTAN (1988)

The reason given nowadays for much scientific research is often, 'to produce interesting ideas'. Not, we notice, to discover *truth*. Once Newton's theory of gravity was true, it is no longer. Truth in these terms can be no more than temporary. Drawing now rarely seeks to frame Platonic ideas or ideal forms, but seeks to keep things moving, to uncover new ideas or motifs. This is, of course, not a view that an artist like Auerbach would accept. He would hold out for that 'decisive moment', the total rightness of a particular configuration. He and his associates are an exception, albeit notable ones. Drawing is, as I have suggested, generally experimental rather than classificatory; open-ended rather than definitive.

It is obvious that the divisions used as chapter headings are only provisional containers: should not Morris be seen as a conceptualist? Or Armando as a painter, pure and simple? Can anything be as perverse as putting Warhol together with figure painters? I have throughout this book, to a great extent, referred to drawing as almost an animate thing, to be hounded and chased through these pages like a rabbit or elusive sprite. This is because drawing presents a set of complex and related issues most of which variously apply to any contemporary artist: the problem of the autographic (who is this one?); the nature of marks (intellectually determined or noise?); the figure (does drawing have a special relationship to the human body – both as draughtsman and model?); meaning (is this a language or a residue of activity?); and so on. It would be adventitious and arrogant to try and provide some grand concluding summation of all this. I would prefer to open up the arguments, rather than close them

down. These arguments will, I hope, be extended by the generally younger artists whom we look at in this chapter. If we are to get an idea of future directions in drawing it will probably be from their work.

We have already noted how often drawing is sucked into blackness: the impervious surfaces of early Marden, in the books of Kiefer, in the shadows and pools of Allington or Cucchi. Black is at once the colour of death, extinction – witness Robert Morris – and the void; but it is also the colour of assertion: black on white. This meditation on black, on its inbuilt paradoxes, is taken further by the work of Donald Sultan. In his drawings forms that we have read elsewhere as black pools or holes become lemons or eggs (Pl 87), precisely poised in space – objects from a still life. But these are things, like a seed or opening flower, about to burgeon into life. His drawings have a *gravitas*, a monumental presence, yet their classical severity is offset by the sensuality of both the medium, above all else by the aura of small charcoal marks around the shapes, and in the forms with their feminine references: lemons as breasts, the tulips often posed like people (Pl 86). The egg with its much looser suggestiveness is now his preferred motif. As with Marden the density of the black is crucial: at least four layers of charcoal and fixative being put down. We have noticed earlier how the space in contemporary drawing, especially in Twombly or Armando, has grown sensitive like a drum-skin stretched tight. This seems equally true of Sultan and of Joel Shapiro – another artist who plays on black as void, or mass. Shapiro's drawings (Pl 88), like his sculptures, are concerned with inserting things and shapes into negative space so

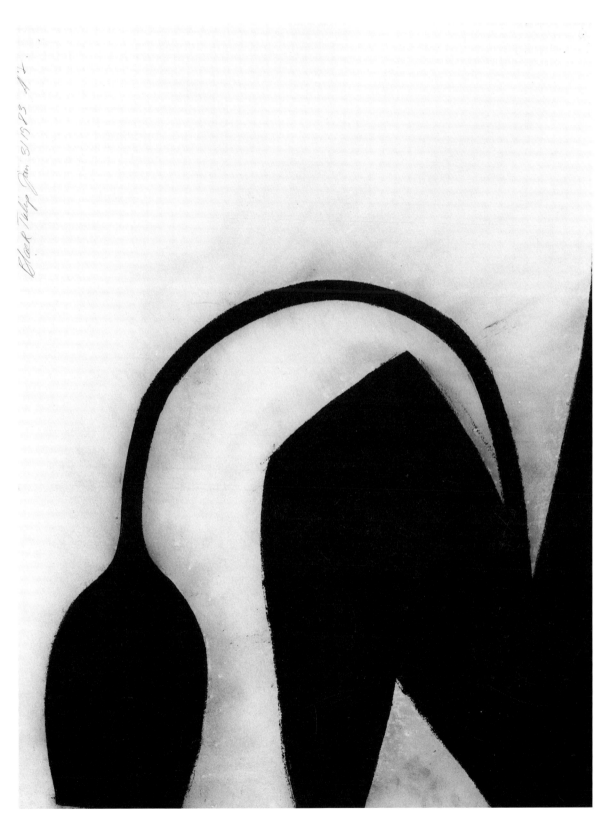

86 DONALD SULTAN. *Black Tulip, Jan 31, 1983*. Charcoal on paper, 127 × 96.5 cm (50 × 38 in). Private collection

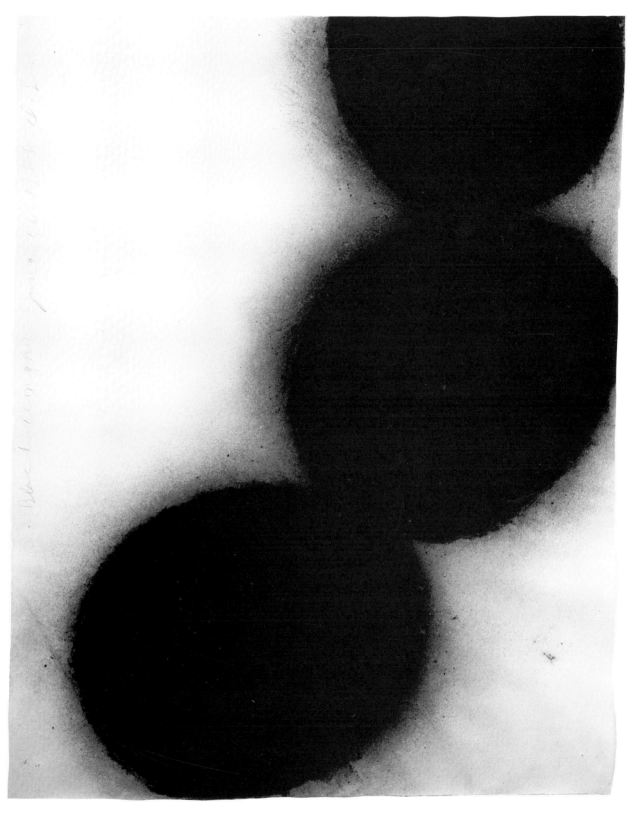

87 DONALD SULTAN. *Black Lemons, June 10, 1988*. Charcoal on paper, 152.4 × 121.9 cm (60 × 48 in). Private collection

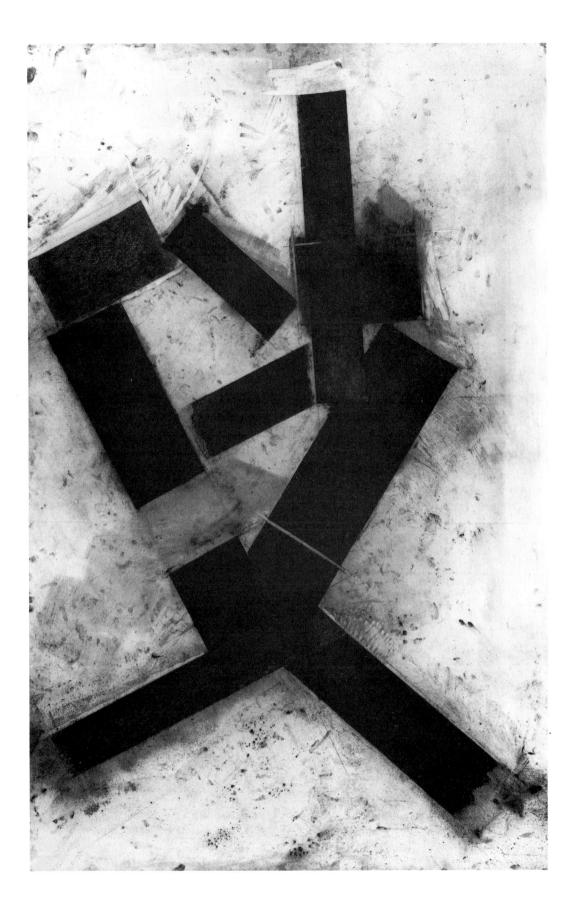

88 JOEL SHAPIRO.
Untitled. 1988. Charcoal
and chalk on paper,
151.1 × 100.3 cm
(59$\frac{1}{2}$ × 39$\frac{1}{4}$ in). Private
collection

that the space becomes charged: we are forced to stand back inadvertently. The potential of shapes and the way they control negative space is his major subject, along with creating strange non-descriptive equivalents to human space and pose.

Drawing geometric constructions is not necessarily a placid activity. For example, for his preface to his recent exhibition of drawings Mel Bochner used part of Vakery's famous evocation of Degas's drawings, which we too have taken as a starting point. There is a sense in Bochner, or Gerald Domenig, of drawing 'intoxicating the draughtsman', a sense in which this is not a logical activity, but a 'violent, self-devouring one'.

Bochner's work in the late sixties was an art of pure logic, of counting, permutating numbers, elaborating basic shapes and proportions. Its poetry was the poetry of pure mathematics, his drawings demonstrations of order. Around 1980 these shapes began to overheat: even a single straight charcoal line creates noise, the friction creates heat, the smallest deviation suggests

change is possible. The noise became louder. Much in the same way as Morris in the *Blind Time* drawings laid down logical parameters for radical or illogical behaviour, Bochner manipulates basic geometric configurations systematically; but the space in which the cubes spiral out in *Via Vanvitelli* (p. 6) with their patina of *pentimenti* suggest other more intuitive logics based on touch. The images, a vortex, cubes flying in space, coloured paper in the propeller shape, are suggestive of turmoil. Mental construction suggests here a different type of mental state.

The Frankfurt artist Gerald Domenig seeks out structures in the world that, collected together, have uncanny connections and meanings. In his photographs he finds unexpected bits of drawing in the residues of the urban life: a bent car radio aerial, a swan's neck against a steel hawser, a shadow across cobbles, a twisted bit of wire by a street corner. The drawings, each on a six by four card, parallel such chance configurations (Pl 89). It is a way of seeing different types of organisation in

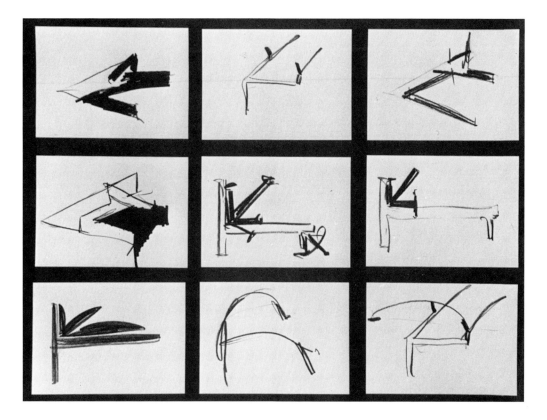

89 GERALD DOMENIG.
Nine Drawings. 1983/4.
Each 10.5 × 14.7 cm
(4 × 5³/₄ in). Collection the artist

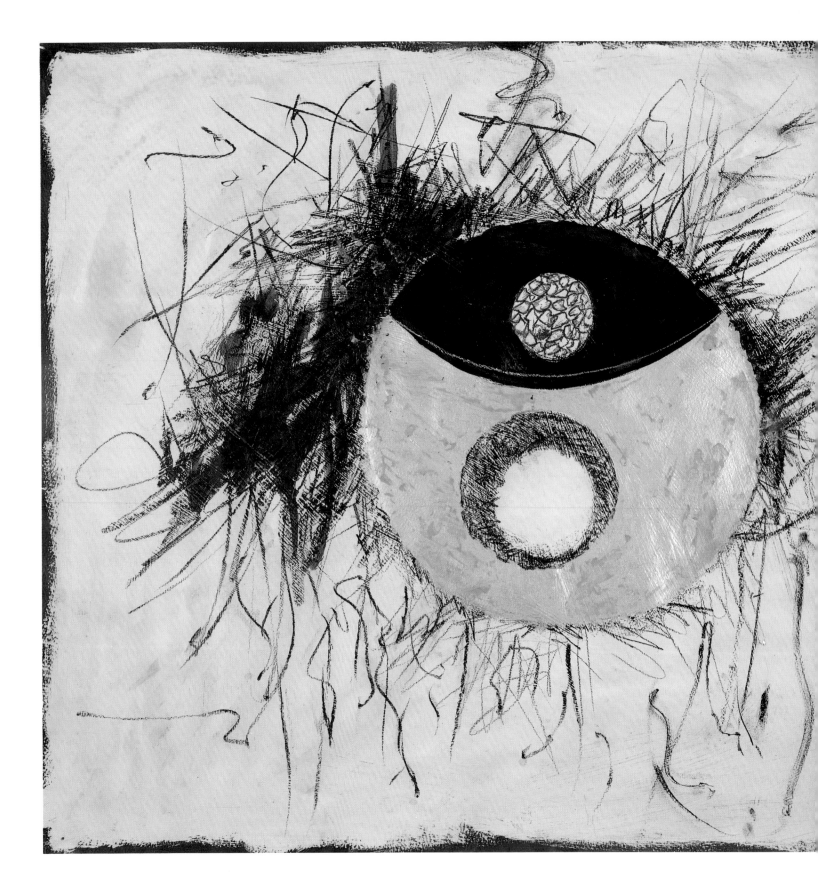

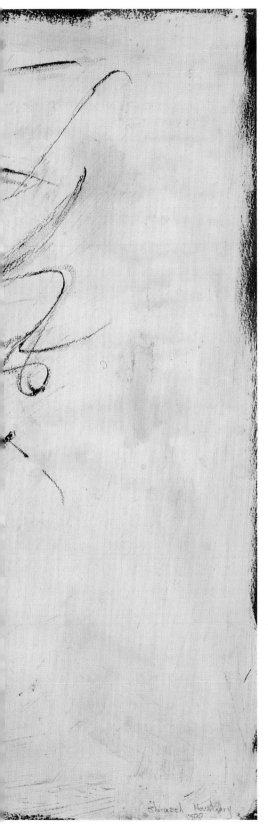

90 SHIRAZEH HOUSHIARY. *Untitled*. 1988. Mixed media, 62.8 × 82.9 cm (24³/₄ × 32³/₄ in). Private collection

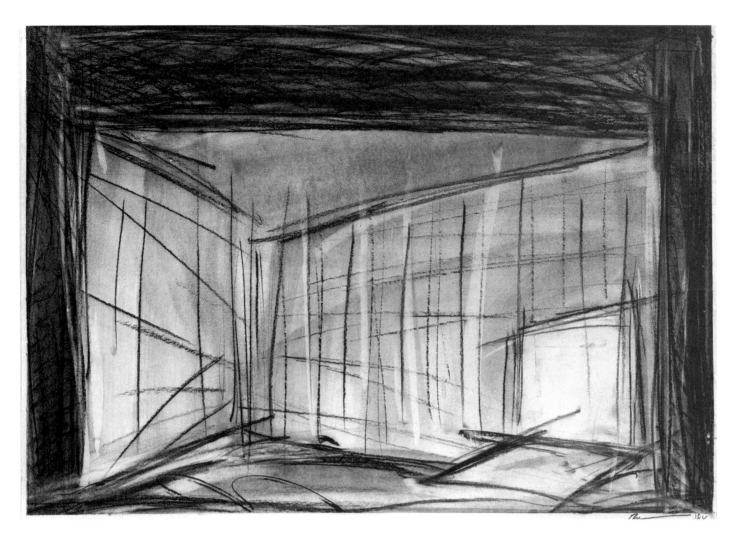

91 ROBERT WILSON.
*The Forest, Act IV,
Epilogue*. 1988. Graphite
on paper, 47.6 × 68.6 cm
(18³/₄ × 27 in). Private
collection

the world, divulged by chance or intuition.

The shape as basis for poetic evocation can be seen clearly in recent drawings of Shirazeh Houshiary. Though the drawing shown here (Pl 90) may be a sculpture being worked out, a contrast of shapes and materials, the lines that swarm around and trail from the central shape suggest the drawing is also an autonomous work generating its own rationale and presence. In earlier drawings the sculptural shapes were intersected by lines of Persian poetry, a role very much taken over by these long undulating marks.

For Rosemarie Trockel there is no direct connection between her sculptures and installation pieces and her drawings. Where the sculptures are carefully preconceived, the drawings are private works

that show a totally different aspect of her artistic personality (Pl 93). Her drawings with their organic and erotic undertones show her, like so many others, to be expanding on the legacy of Beuys. As in Beuy's work texture and curious colours help invoke pre-conscious sensations.

As we have noted in Bruce Nauman's work the conceptualizing of things that are to be made can result in interesting drawings. Similarly many drawings by architects and designers have an autonomous life as drawings *per se*. I am thinking less perhaps of the immaculately finished presentation drawings of someone like Morris Graves as of the drawings for furniture and building projects by Aldo Rossi or Hans Hollein. These have a far greater resonance and iconographic richness than

is necessary for a blueprint.

In this context the work of Robert Wilson is especially interesting. Trained as an architect, but initially a painter, he has worked as both performance artist and stage producer. Drawing is his way of inventing stage moods, settings and shifts: the drawings should properly be seen in extended sequences. With his ability to conjure light and dark, the drawings take on a validity of their own. Indeed they become a different aspect of his vision, one in which curiously the figure never appears: the setting and the marks that create it have sufficient drama (Pl 91).

(In one respect this book inevitably gives an incomplete picture, for a whole range of drawing goes into private sketchbooks. Such sketchbooks rarely emerge until after the artist's death, the artist keeping them as working material throughout their life. Only two genuine sketchbook drawings (by Le Brun and Borofsky) appear here.)

In the opposite direction it is difficult to convey in the printed page just how large drawings by

Walker, Borofsky, Morris, Cahn or Klossowski are. The same is true of Pat Steir: because drawing for her is the tracing and tracking of the body in movement the paper must be large enough to contain gesture involving her complete body, lines that are several feet long. Like so many, her grounding was in conceptual art: for all the spontaneity of the marks the precepts and conditions are laid down. Quoting from Ensor and Japanese woodcuts of waves she builds up a large surface that is, if not covered, modulated by marks and the light they hold at interstices (Pl 94). In her images of waves, water is a metaphor for drawing which can itself be seen as a metaphor for human consciousness.

She uses drawing to recreate the past, by style and image, in the present. This is true of others: Hughie O'Donoghue amongst them. His drawings re-materialize the tonalities of a Rembrandt print: when in Rembrandt a tunnel of light slants down over the crucifixion, here, in O'Donoghue's drawing, light cascades on the writhing forms of a tree (Pl 92). On this large scale the lustre of charcoal

92 HUGHIE O'DONOGHUE. *Olive Tree III*. 1987. Charcoal and conte, 102 × 152 cm (40 × 60 in). Private collection, USA

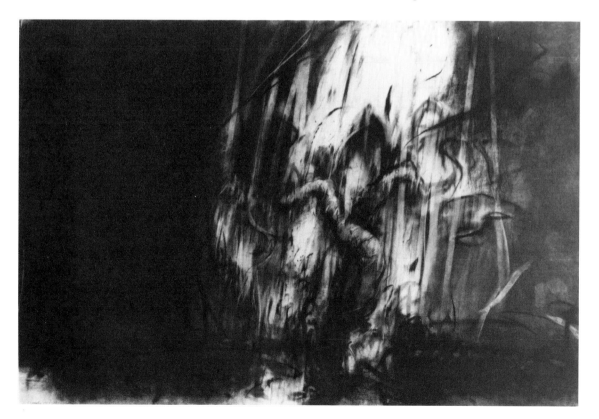

93 ROSEMARIE TROCKEL. *Untitled*. 1988. Mixed media,
30 × 21 cm (11¹/₂ × 8 in). Private collection

94 PAT STEIR. *Christ Calming the Storm after Ensor*. 1984.
Mixed media and graphite, 152.4 × 243.8 cm (60 × 96 in).
Private collection

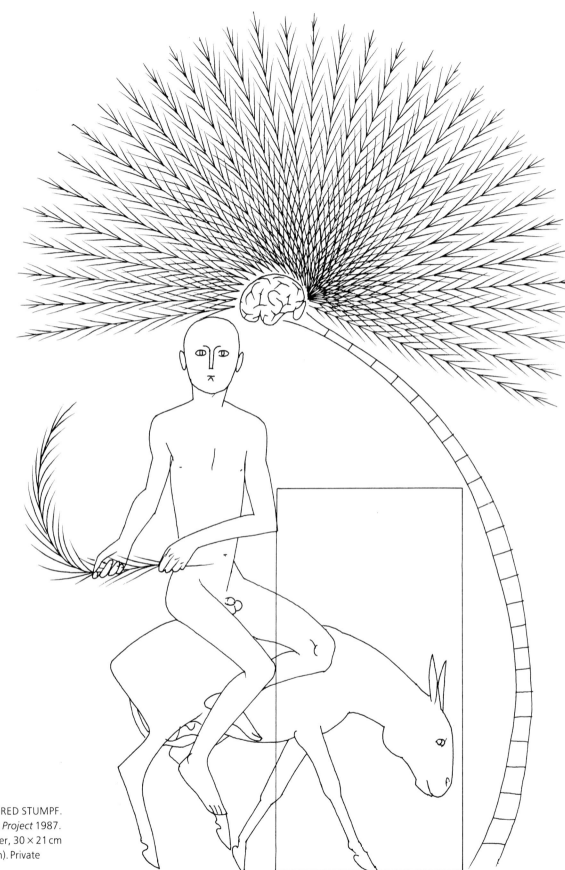

95 MANFRED STUMPF.
From *Palm Project* 1987.
Ink on paper, 30 × 21 cm
(11¹/₂ × 8 in). Private
collection

and conté, together with the strips of paper torn by the pressure of O'Donoghue's hand, is like velvet. Such textural pleasure complicates the apparent transcendentalism of the image.

One challenge facing drawing is in the use it can make of the new technology. Hockney's use of the photocopier is well known. Pearlstein amongst others has played with a computer as a conceptualizing tool. Machines, by Tingueley or Harold Cohen, that actually make drawings have been around for some time and even seem old fashioned. An especially interesting use of the computer is that by Manfred Stumpf, where it enables him to present his disturbing linear drawings with a haunting precision (Pl 95). But for most artists the need for the actual presence of hand on paper or support is essential – using a computer would miss the point.

Poignancy is the characteristic common to the figure inventions of David Austen and Adrian Wiszniewski. For Austen these are isolated, whittled down to their smallest aspect (Pl 97): like Stumpf's this is an art of distillation where the precision of each contour is essential. It is like Clemente's drawing without the effusiveness: an art where any apparent existential angst is offset by a

delicacy of placement similar to that in Sultan or Shapiro. It is not surprising to find that in much of his recent work the motif has become abstract: it is the weight, rather than physiognomy, of the figure that is important. Wiszniewski, in contrast, allows his line to meander across the page, or else diffuse into a stream of delicate strokes and dabs like cross hatching let loose. The gawkiness of the figures is matched by the crinkle-crankle nature of these modulations. Unlike Austen his allegories are relatively explicable: here two scientists have taken apart a bird and are putting it together again (Pl 98). They have got it wrong: it will not be able to digest the hybrid animal they have put in its beak. Drawn at the time of Chernobyl it is about our disharmony with nature, a disharmony at odds with the gentle touching of the gouache on the paper.

From when Duchamp drew the moustache on the *Mona Lisa* to Hambleton's figures on the street drawing has been persistently used as intervention. Such intervention is at its most potent politically in a work made by Miriam Cahn in 1979. Across the monolithic concrete supports of a controversial motorway interchange in Basle she drew emotionally charged images (Pl 96): a bed, radio masts (that looked like stitched wounds), battle-

96 MIRIAM CAHN.
My being a Woman is my Public Persona 1979/80. Installation shot, Basle. Private collection

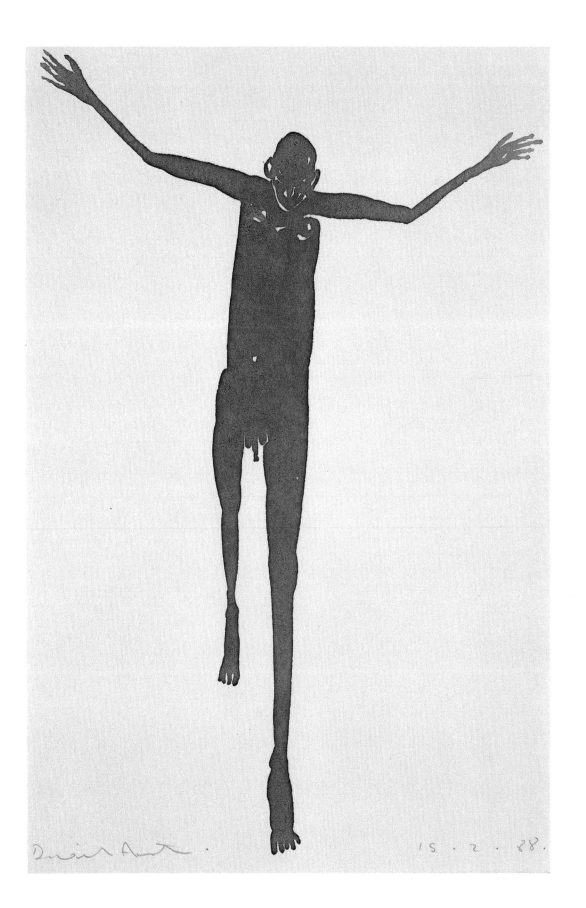

97 DAVID AUSTEN.
Untitled. 1988. Ink,
25 × 16.4 cm (9⁷/₈ × 6³/₈ in).
Private collection

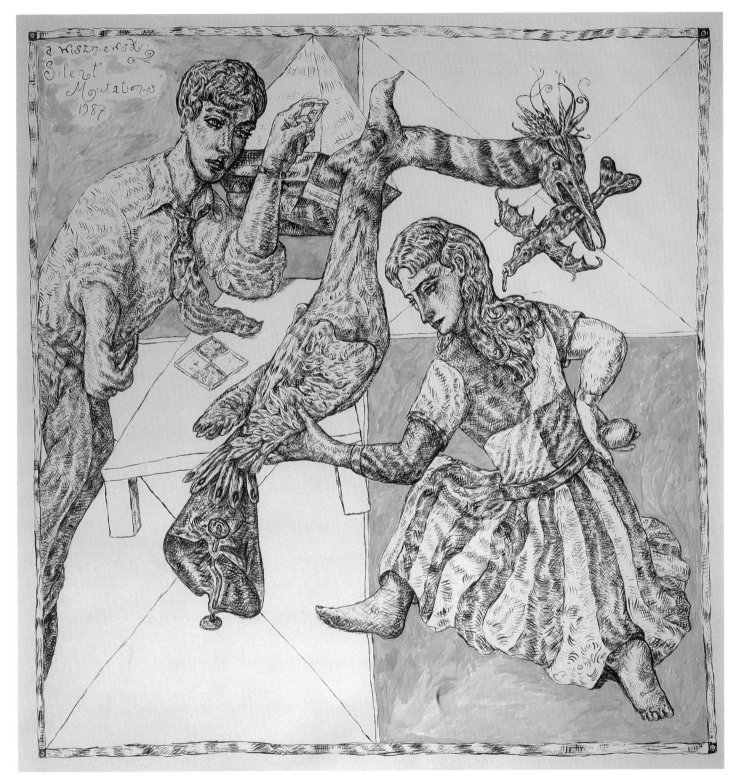

98 ADRIAN WISZNIEWSKI. *Silent Mutations*. 1987. Gouache on paper, 254 × 244 cm. (100 × 96 in). Private collection

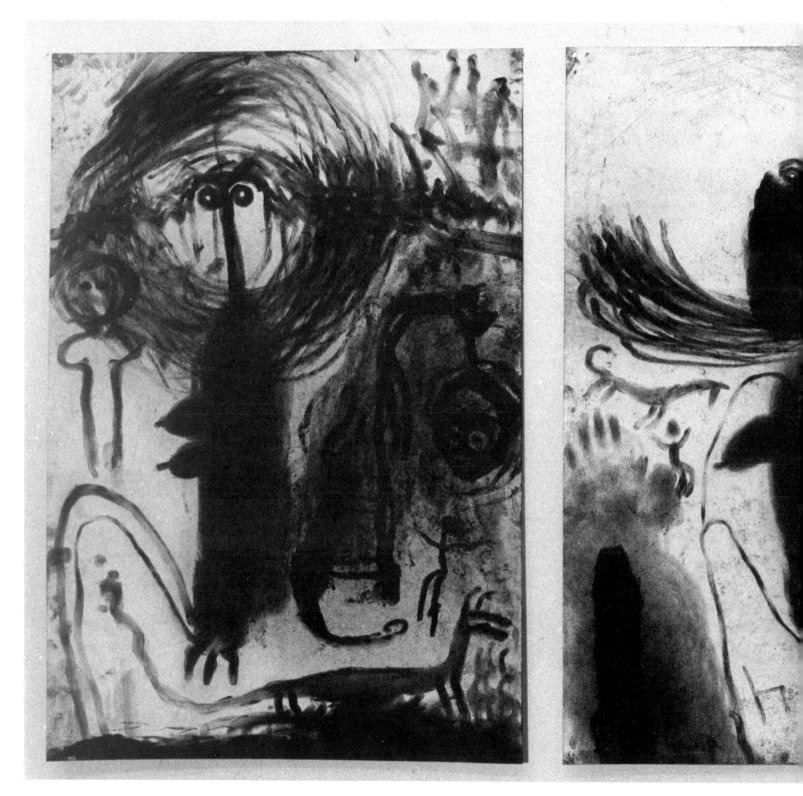

99 MIRIAM CAHN.*L.I.S seen precisely*. (L.I.S. = *Lesen in staub* or 'reading in the dust'). 1987. Each 170 × 100 cm (67 × 39¹/₄ in). Collection the artist

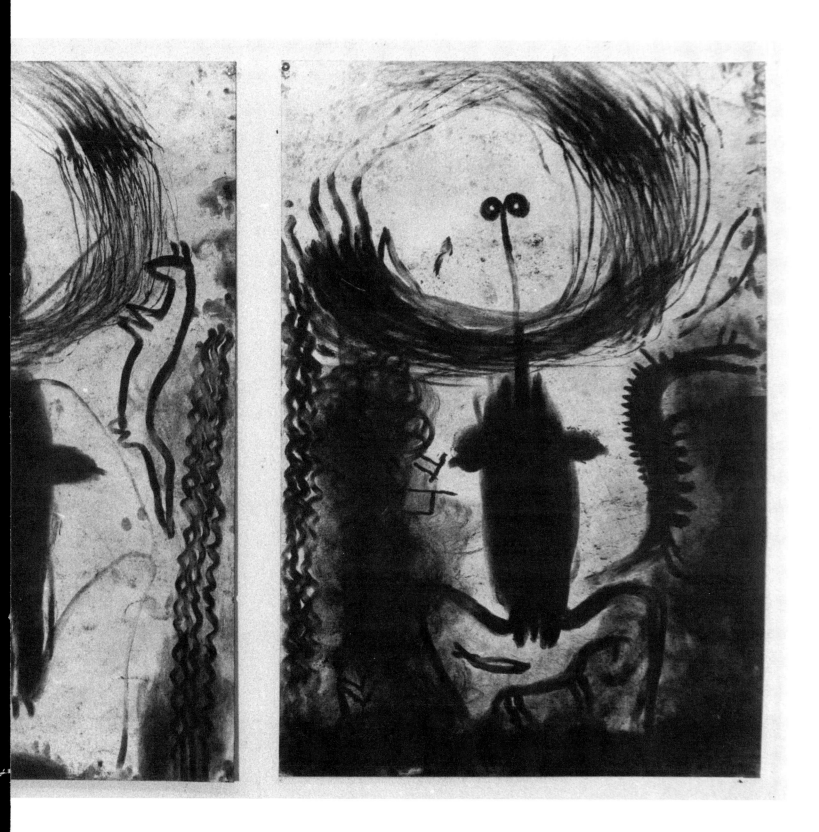

100 AVIS NEWMAN. *Figure Innominate V*. 1984. Charcoal on paper, 137.2 × 101.6 cm (54 × 40 in). Private collection

101 AVIS NEWMAN. *Lassitude before Words*. 1987. Mixed Media on canvas, 274.5 × 406.5 cm (108 × 160 in). Private collection

ships and menstrual blood flowing from houses. It was a way of opposing the bureaucratic and inhumane with the personal and metaphoric.

It is this aspect of drawing that is most crucial in its role in cultural health. This is most clearly seen in the work of women artists like Miriam Cahn or Sue Arrowsmith. Cahn, in her studio works, will work on a vast sheet of paper, getting down on her hands and knees, rubbing chalk dust across and into it. The paper becomes covered with the dust. Only after the stray dust is blown away can the disclosed image be seen (Pl 99). She does not hold with being precious about drawing, the idea and the activity are more important. Pointedly she does not fix her drawings. Drawing is for her a way of being: 'I spread the dust onto the paper and that is really old-fashioned, a lost process which maybe wise women used in bygone days. Let's say its similar to reading tea-leaves. The process is called "reading in the dust" I am working as a complete person, and that is complete subjectivity.'

It is especially in the work of women artists that we see the intimate relationship of the body and the traces it leaves in drawing. Indeed, perhaps it is most particularly in the work of women artists, as they develop and extend their voices, that we see the future of drawing. Just as the issue of a woman's different body has been brought into cultural politics, so the issue of their different body language becomes a new major element in the dialectic of drawing.

The drawings of Avis Newman are like compendia of the types of traces the gesturing body can make in the mythic space of drawing (Pl 100). In their references, materials and formal variety they are amongst the most complex drawings being made. As is made clear in her smaller drawings, the evocation or conjuring up of figures is the crux of her art. These large canvases become like a sensitive skin on which are to be described bruises, scars, fugitive sensations of limbs flexed, emotions passing. The echo of cave drawings is obvious (Pl 101): like them they create a charged space in which the viewer becomes involved.

Arrowsmith, like Rainer, has overdrawn photographs of her own face, but for her it was a process to do with questioning identity: with questioning how identity is created and mediated to the watching world. In a work of 1984, *Nine Accidents* (Pl 102), she traced herself on nine separate sheets of paper, crouched often in a foetal position, drawing herself again and again as if to give birth to multiple possibilities, the line fluctuating constantly. The work is especially poignant for an age where the body of a woman is continually projected as an object for others. This was an act of reclamation.

If we seem to have come full circle, from a woman tracing her lover's profile to a woman tracing her own body, the differences are none the less revealing. The total body, not just the physiognomy is now involved; drawing is made in part against dominant representations in our society; it consciously sets out to gather energy that has been lost. But above all else, whether it is biased to the traditional or the instinctual, we realize that in its essence drawing is, as Kiefer said of the art of Beuys, 'joyous': it is an affirmation.

102 SUE ARROWSMITH. *Nine Accidents*. 1984. Charcoal on paper, nine panels, each 100.9 × 80 cm (39³/₄ × 31¹/₂ in).
Private collection

SELECTED BIBLIOGRAPHY

Lawrence Alloway. 'Sol LeWitt: Modules, Walls, Books'. *Artforum* XIII/8, 1975

Roland Barthes (Introduction). *Catalogue Raisonee des Oeuvres sur Papier, 1973–1976*. Yvon Lambert, 1979

Heiner Bastian and Jeannot Simmen. *Joseph Beuys Drawings*. Prestel Verlag, 1980

Germano Celant. *Penone*. Electra, 1989

Magdalena Dabrowski. *The Drawings of Philip Guston*. Museum of Modern Art, New York, 1988

John Elderfield. *The Modern Drawing: 100 Works on Paper from the Museum of Modern Art*. Thames and Hudson, London, 1984

Exhibition catalogue. *Armando, 100 Drawings, 1952–1984*. Museum Boymans-van-Beuningen, Rotterdam, 1985

Exhibition catalogue. *Joseph Beuys Drawings*. Victoria and Albert Museum, 1983

Exhibition catalogue. (Introduction by R.B. Kitaj) *The Human Clay*. Hayward Gallery, London, 1976

Exhibition catalogue. *Sol LeWitt Wall-drawings, 1968–1984*. Stedelijk Museum, Amsterdam, 1984

Exhibition catalogue. *Ian McKeever*. Kunsthalle Nurnberg, 1982

Exhibition catalogue. *Bruce Nauman Drawings, 1965–1986*. Museum fur Gegenwartskunst, Basel

Exhibition catalogue. *Sigmar Polke Drawings, 1962–88*. Kunstmuseum, Bonn, 1988

Rudi Fuchs. *Richard Long*. Thames and Hudson, London, 1986

Anselm Kiefer. *Watercolours, 1970–1982*. With notes on plates by Anne Seymour. Antony d'Offay Gallery, London, 1983

Alicia Legg. *Sol Lewitt*. Museum of Modern art, New York

Marco Livingstone. *David Hockney: Faces 1966–1984*. Thames and Hudson, London, 1987

Marco Livingstone. *R.B. Kitaj*. Phaidon, Oxford, 1985

'R.B. Kitaj and David Hockney discuss the case for a return to the figurative . . .' *New Review*, February 1977

Brice Marden. *Suicide Notes*. Editions des Massons, 1974

Parkett No. 8, 1986. Special issue: Markus Raetz

Nicholas Penny and Robert Johnson. *Lucian Freud: Works on Paper*. Thames and Hudson, London, 1988

John Perreault. *Philip Pearlstein, Drawings and Watercolours*. Abrams, New York, 1982/8

Philip Rawson. *Drawing*. Pennsylvania University Press, Second Edition, 1987

Philip Rawson. *Seeing Through Drawing*. B.B.C., 1979

Bernice Rose. *Drawing Now*. Museum of Modern Art, New York, 1976

Mark Rosenthal. *Jonathan Borofsky*. Abrams, New York, 1984

David Shapiro. *Jasper Johns Drawings, 1954–1984*. Abrams, New York, 1984

Coosje Van Bruggen. *Bruce Nauman*. Rizzoli, New York, 1988

INDEX